NATURE'S CHAOS

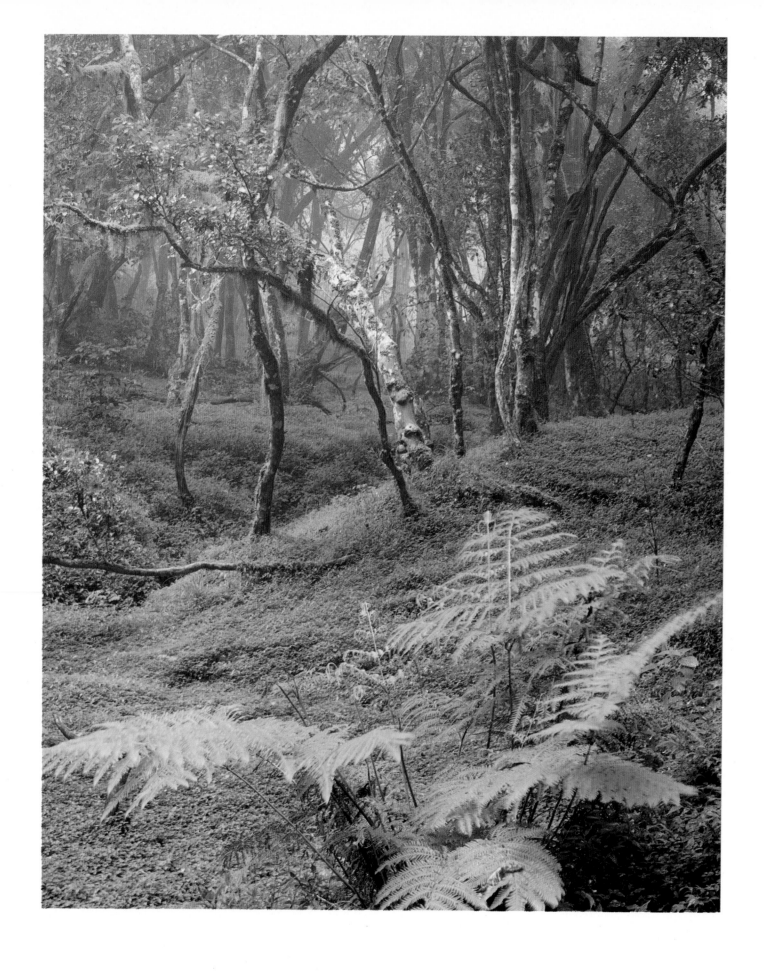

Ferns in forest, Mt. Meru, Arusha National Park, Tanzania, Africa, 8 July 1970

NATURE'S CHAOS

Photographs by

ELIOT PORTER

Text by

JAMES GLEICK

Compiled and Edited by Janet Russek

VIKING

VIKING

Published by the Penguin Group

Viking Penguin, a division of Penguin Books USA Inc.,
375 Hudson Street, New York, New York 10014, U.S.A.

Penguin Books Ltd, 27 Wrights Lane,
London w8 5tz, England

Penguin Books Australia Ltd, Ringwood,
Victoria, Australia

Penguin Books Canada Ltd, 2801 John Street,
Markham, Ontario, Canada L3R 1B4

Penguin Books (N.Z.) Ltd, 182–190 Wairau Road,
Auckland 10, New Zealand

Penguin Books Ltd, Registered Offices:
Harmondsworth, Middlesex, England

First published in 1990 by Viking Penguin,
a division of Penguin Books USA Inc.

10 9 8 7 6 5 4 3 2 1

LIBRARY OF CONGRESS CATALOGING IN PUBLICATION DATA
Gleick, James.
 Nature's chaos / text by James Gleick ; photographs by Eliot
Porter.
 p. cm.
 Includes bibliographical references (p.).
 1. Nature photography. 2. Chaotic behavior in systems.
I. Porter, Eliot, 1901– . II. Title.
TR721.G58 1990
779′.3—dc20 90–50041

Printed in Japan

FOREWORD

Ever since I became a photographer, my interest has been in the natural world. My sense of wonder was first aroused by the physical and biological mysteries of science, and when I became interested in photography the subjects that occupied my attention were those primarily connected with the natural scene. Nature became intimately associated with my perception of beauty.

To most people, I am sure, the beauty of nature means such features as the flowers of spring, autumn foliage, mountain landscapes, and other similar aspects. That they are beautiful is indisputable; yet they are not all that is beautiful about nature. They are the peaks and summits of nature's greatest displays. But underlying and supporting these brilliant displays are slow, quiet processes that pass almost unnoticed from season to season—unnoticed, that is, by those who think that the beauty in nature is all in its gaudy displays. Yet, how much is missed if we have eyes only for the bright colors. Nature should be viewed without distinction. All her processes and evolutions are beautiful or ugly to the unbiased and undiscriminating observer. She makes no choice herself—everything that happens has equal significance. Withering follows blooming, death follows growth, decay follows death, and life follows decay in a wonderful, complicated, endless web the surface beauties of which are manifest to a point of view unattached to vulgar, restricting concepts of what constitutes beauty in nature.

When I gave up medicine for photography, I first photographed only landscapes, static subjects such as mountains and rivers that were always in the same place. Gradually I moved away from a preoccupation with views and became more and more engaged by the details. At first, I perceived the order of nature in an infinite variety of beautiful subjects. Later, however, I began to see that, in a deeper sense, individual parts of the scene were completely independent of one another in the field of living things. When I looked at nature as a whole, I realized that it had a random quality, that nothing remained as it had been, nothing could be seen as part of a unified whole. Although I was aware that it was possible to select and photograph fragments of nature that expressed the idea that nature was an orderly process, I began to realize that my photographs also emphasized the random chaos of the natural world—a world of endless variety where nothing was ever the same.

Then I read James Gleick's book *Chaos,* and his distillation of the new science of chaos helped me to crystallize my own thoughts about how my photographs expressed disorder in nature. After reflecting on this idea, I suggested to Janet Russek that many of my pictures seemed to be about disorder in nature, and we started to select some images for a possible book on this topic. Soon afterward Janet Russek got in touch with James Gleick when he came to speak in Santa Fe. We proposed to him that we do a book together on the disorder of nature.

When I started selecting photographs for the book from the various places I have been, including Antarctica, the Galápagos Islands, Africa, Asia, and the United States, I discovered that I had many more photographs relevant to the concept than I had originally thought. In fact, there were so many appropriate images that it was difficult to reduce the

selection to an acceptable number. With Janet Russek's help, I made a preliminary selection of 250 photographs.

James Gleick reviewed the transparencies we had selected and, with his help and that of Eleanor Caponigro, the book's designer, we reduced the number of photographs to about 103 — 96 of which are previously unpublished. At that point it seemed virtually impossible to eliminate any more without discarding some that we considered especially appropriate and important for illustrating the idea. At the same time, the selection process seemed somewhat like a game of chance: it seemed to make little difference whether we eliminated a picture that was among our final selections and substituted one that we had excluded previously. This fact seemed to underscore how valid the concept of nature's chaos was in connection with these photographs.

The images selected for this book are mostly details of nature which emphasize how nature's apparent disorder can be reduced to aesthetically stimulating fragments. Although subjects such as mosses, lichens, or leaves that have just fallen are not orderly at all, when viewed as detailed sections, they become orderly. This process suggests a tension between order and chaos. When I photograph, I see the arrangement that looks orderly, but when you consider the subjects as a whole or on a larger scale, they appear disorderly. Only in fragments of the whole is nature's order apparent.

ELIOT PORTER

NATURE'S CHAOS

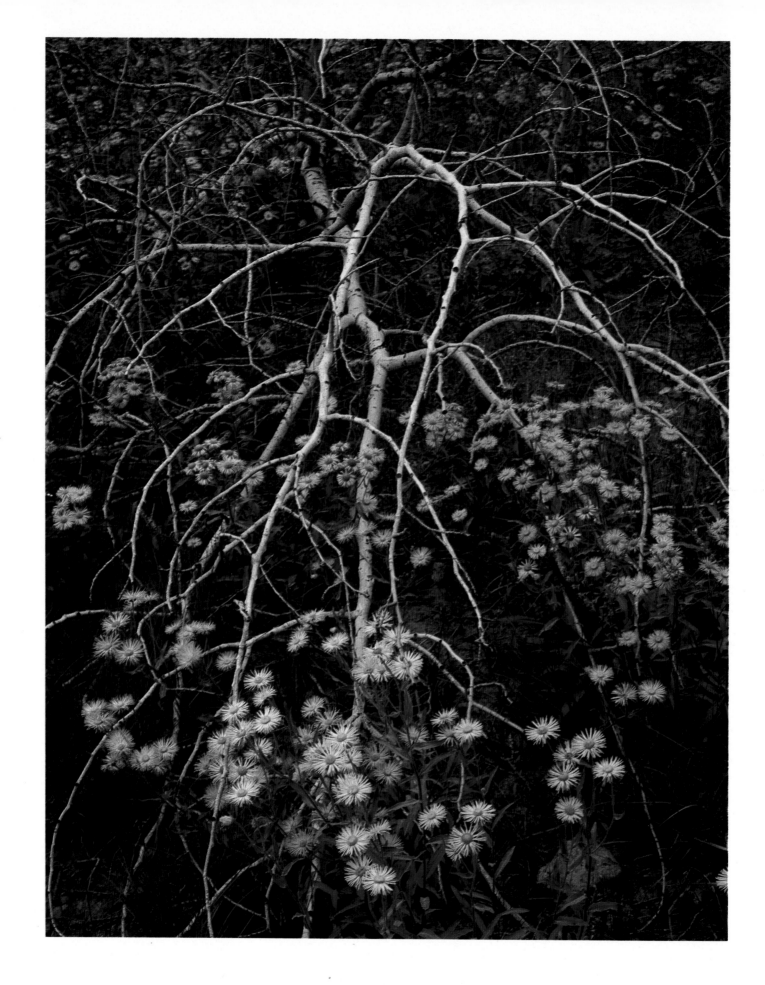

10. *Asters and dead branch, Cumbres Pass, Colorado, 10 August 1957*

When a child draws a tree, a green mass sits atop a brown trunk, as if the basic shape were like a Popsicle. A child's cloud is a smoothly rounded bulk, perhaps with wavy or scalloped edges. These are not the clouds we see. They are highly stylized forms, like the international symbols for Railroad Crossing or No Smoking. As children or adults, we own a repertoire of such stylized images, like ideograms in Chinese painting. First they help us see—for without such templates, our minds are powerless to sift the welter of sensations that bombard our eyes and ears. But they hinder our seeing, too. The rivers, the clouds, the snowflakes of our usual perceptual tool kits miss much of nature's true complexity: the intricate recursion, the convoluted flows within flows within flows. Our mental lightning bolts are Z's, our volcanoes are inverted and decapitated cones, our rivers are lines. Nature's are not so simple.

Imagine a river. Not a real river, surface rippling in a squall, trout quivering near submerged rocks, currents carving the banks. Nothing so fancy—just imagine a river's basic shape, the shape you would draw on a piece of mental scratch paper.

Inevitably and universally, we imagine a line, drawn with some curve or wiggle. When we speak of a river by name, we think of an entity flowing from one place to another, source to outlet, from a mountain spring, perhaps, to the sea. The thing people call the Rhine rises from the ice of a Swiss glacier two miles above sea level and winds to the North Sea. According to the conventions of nomenclature, its tributaries, the Main, the Moselle, the Ruhr, are different rivers. North America's longest named river is the Mississippi—or is it the Missouri, half again as long, though a mere tributary? Actually, geographers and quizmasters know that the continent's longest river is a nomenclatural

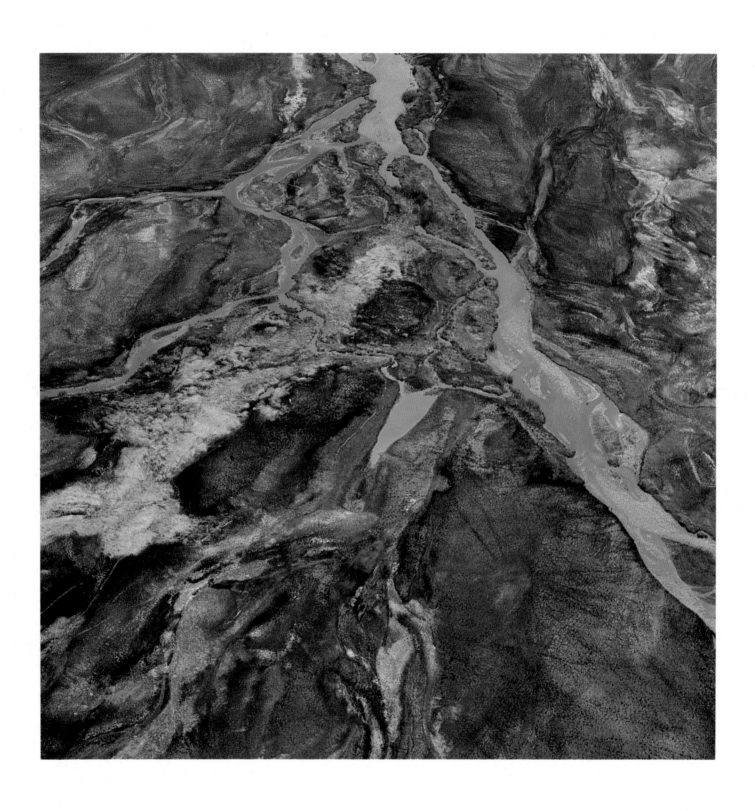

12. *Estuary on shore of Lake Natron from the air, Tanzania, Africa, 15 October 1970*

hybrid (call it the "Mississippi Missouri Jefferson Beaverhead Red Rock") cascading and meandering from the Northwest Rockies to the Gulf of Mexico, flowing—according to our sense of the river's essential, Platonic form—in a line.

It is not so. Our imaginations mislead us. In reality, a river's basic shape—and it does have a basic shape, repeated wherever nature empties the land of water—is not a line but a tree. A river is, in its essence, a thing that branches. So are most plants: trees themselves, bushes, ferns. So is lightning, contrary to our common lightning-bolt stereotype, which is a sort of stretched Z. So is the human lung, a tree of ever-smaller tubes: bronchi, bronchia, and bronchioles, intertwining with another tree, the network of blood vessels.

North America's longest river actually spans thirty-one American states and two Canadian provinces. It embodies without discrimination the great tributaries we think of as separate rivers; it is the Mississippi-Missouri-Ohio-Tennessee-Arkansas . . . Except in human perception and language, nothing separates its few wide and deep stretches from its many small and narrow ones. Although it flows inward toward its trunk, in geological time it grew, and continues to grow, outward, like an organism, from its ocean outlet to its many headwaters. In the vernacular of a new science, it is fractal, its structure echoing itself on all scales, from river to stream to brook to creek to rivulet, branches too small to name and too many to count.

Untamed, undomesticated, unregulated wildness. Nature paints its scenes without regard for conventional order, for straight lines or Euclidean shapes. Luckily so—the human mind seems to take as little

pleasure in a straight line as in pure formlessness. The essence of the earth's beauty lies in disorder, a peculiarly patterned disorder, from the fierce tumult of rushing water to the tangled filigrees of unbridled vegetation.

But that is a new conceit. The idea itself is a luxury indulged by a species finally winning a many-thousand-year struggle against nature, and finally having second thoughts. Until lately, people found nature most beautiful when it was tamed, arranged, and dressed up in an English or Italianate or Japanese formal garden: flowers in groups and rows; the terrain flattened or landscaped in geometrical terraces; trees pruned to smooth green contours; rocks and wild grasses ordered or banished altogether. Such gardens must have given pleasure to the natural philosophers of earlier centuries, as they, too, struggled to order a messy universe. They reveled in the clockwork regularity that Galileo, Kepler, and Newton exposed in the night sky. They devised a calculus that made possible a coming era of mechanical and electrical engineering. They built a science well equipped for managing the orderly phenomena with which nature sometimes favors us. Like the formal garden, the edifice of classical science served as a haven against an untamed wildness. Scientists sometimes forget how helpless they were to understand nature's chaotic side: turbulent flows in liquids and gases, unpredictability in forecasting storms and economic cycles, disorder in lasers and electronic circuits, erratic rhythms in the heart and brain.

Lately researchers have found a new understanding of wildness in the study of chaotic and complex systems. As in the earliest days of human science, they are drawing inspiration from the natural world. They find, waiting within the disorder of grasses strewn in a meadow

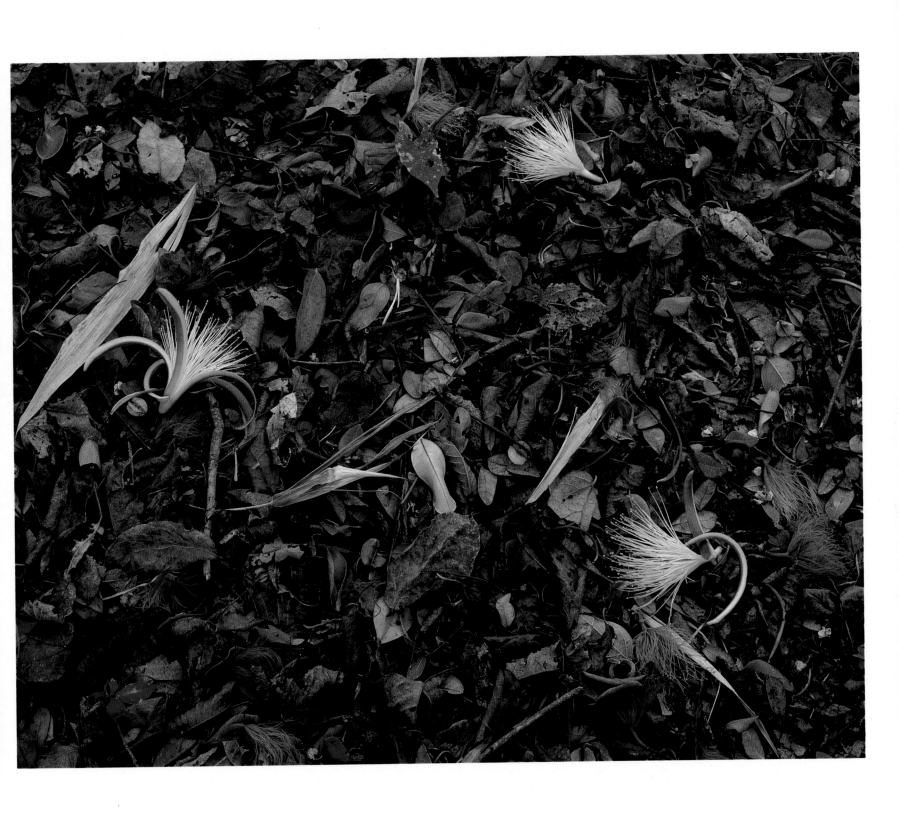

Dry tropical forest floor, Palo Verde Park, Costa Rica, 14 March 1984

or talus across a rock face, uncanny kinds of structure, more subtle and intricate than any human gardener or sculptor could arrange. There is a sense of danger in the shifting perception, as Michael Barnsley, a mathematician studying chaos, has written: "You risk the loss of your childhood vision of clouds, forests, galaxies, leaves, feathers, flowers, rocks, mountains, torrents of water, carpets, bricks, and much else besides. Never will your interpretation of these things be quite the same."

To see nature chaotically, look again. A painter hoping to represent the choppy ocean surface can hardly settle for a regular array of scalloped brush strokes, but somehow must suggest waves on a multiplicity of scales. A scientist puts aside an unconscious bias toward smooth Euclidean shapes and linear calculations. An urban planner learns that the best cities grow dynamically, not neatly, into complex, jagged, interwoven networks, with different kinds of housing and different kinds of economic uses all jumbled together. And in a lifetime's exploration of nature the photographer Eliot Porter has freed himself from a conventional sense of orderliness. The images he has assembled here find symmetry, but not the simple left-right symmetry of a child's paper cutout—rather, nature's own symmetry, a symmetry of textures, in which the large mirrors the small. Disequilibrium, too, has a home here. Nature is balanced only in rhetoric; in reality few of the earth's processes settle into an even kilter. Porter's pictures of a blowhole spewing steam in the Galápagos or of ice heaving itself into pockmarked hillocks in Antarctica celebrate nature out of balance. A cloud, condensing at a critical boundary in roiling air, is nothing more or less than the visible signal of the atmosphere's disequilibrium. When Porter finds harmony, it is rarely a static and balanced harmony—rather, a wavering, lurching, animating harmony.

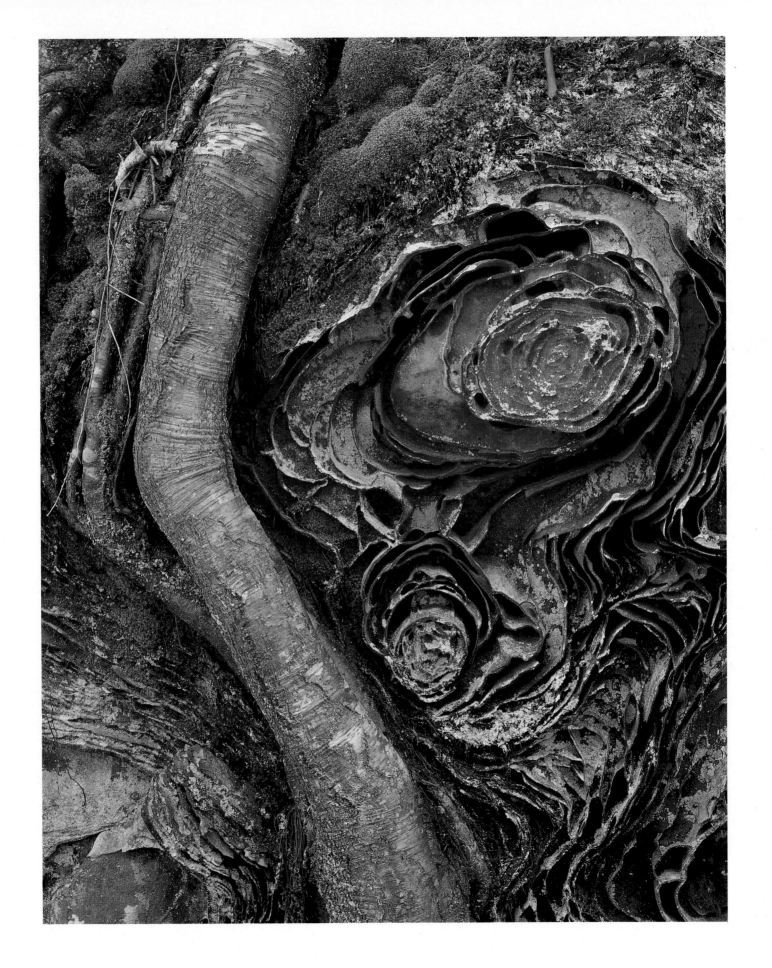

Roots and eroded sandstone, Gray's Arch Trail, Red River Gorge, Kentucky,
18 April 1968

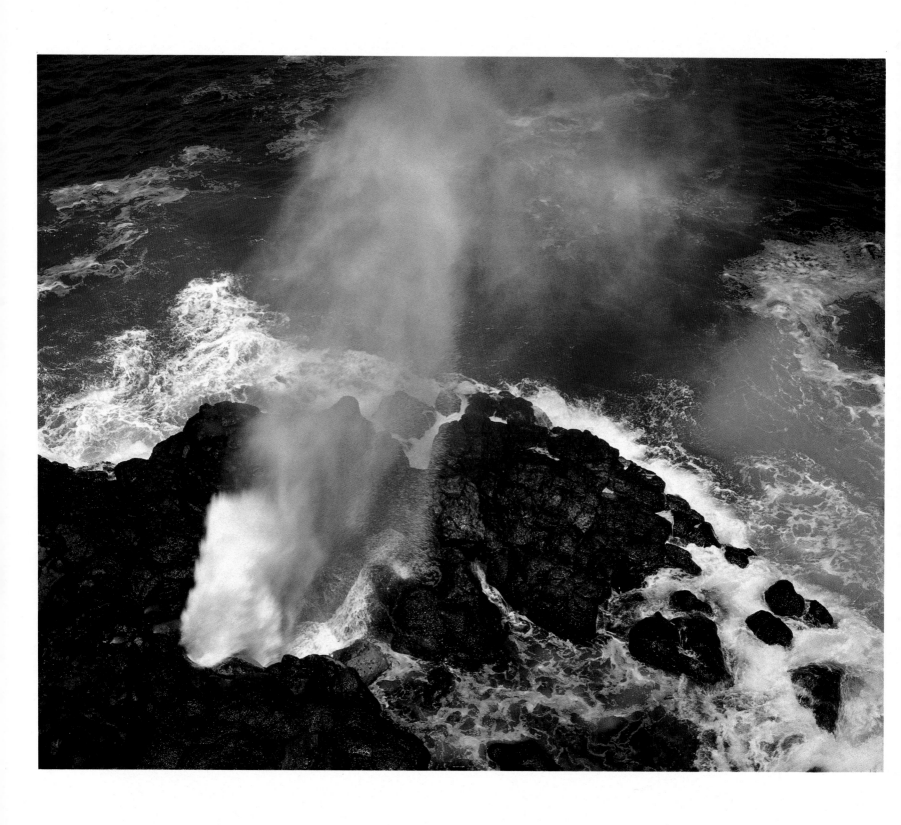

18. *Blowhole with rainbow, Hood Island, Galápagos Islands, 29 May 1966*

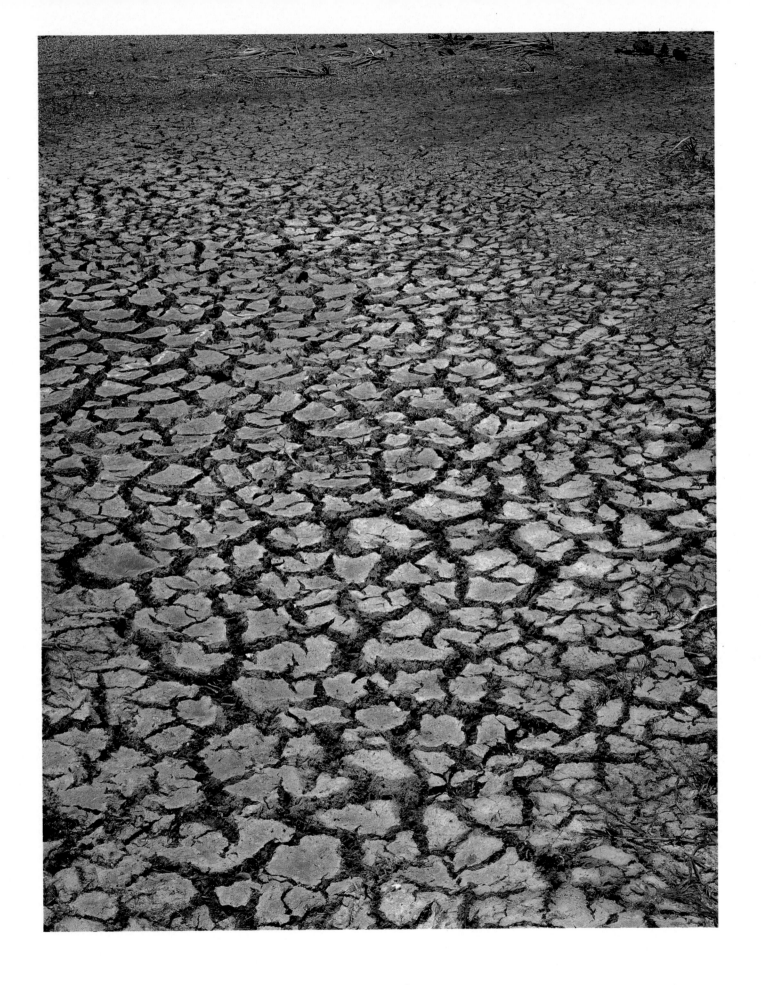

Cracked mud, Palo Verde Park, Costa Rica, 14 March 1984

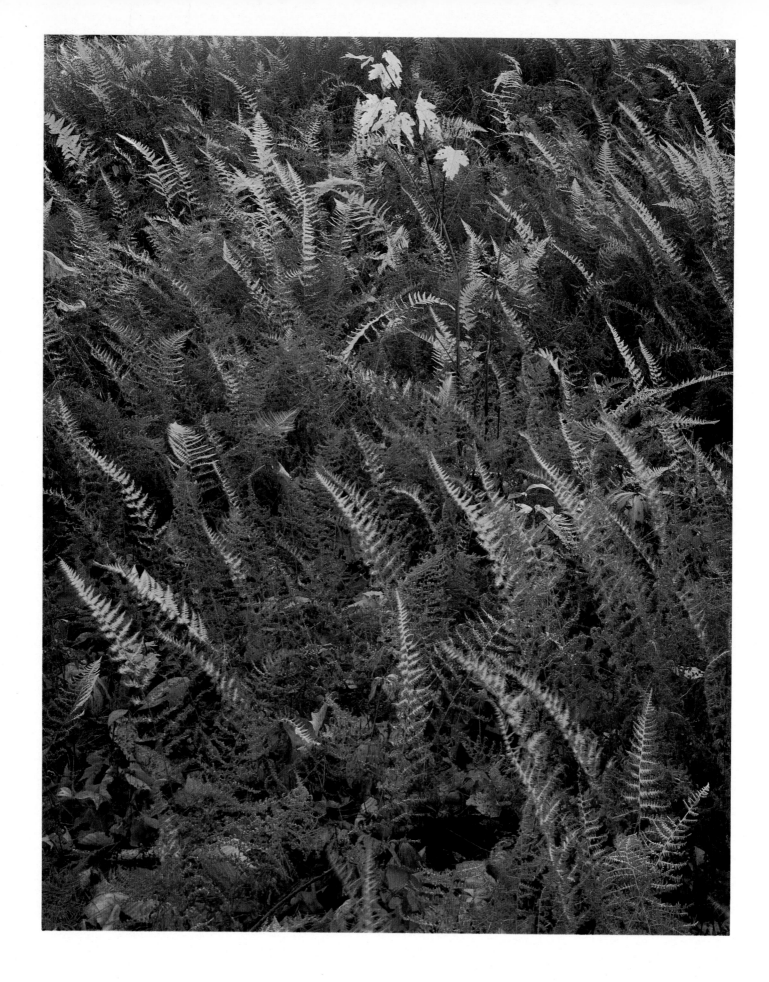

Hay fern, Tamworth, New Hampshire, 8 October 1956

Fractal patterns have found their way into the usually disjoint worlds of visual artists and computer hobbyists. Scientists have found a vocabulary and a tool kit for understanding patterns that had seemed annoyingly random—cracking, for example, in earthquake-prone rock or in stressed metals. But fractals are also entering the cultural vocabulary as pictures, more and more familiar: fractal "dragons," composed of ever-smaller triangles, a bump on a bump on a bump on a bump, or fractal lattices of squares on different scales, always with a hall-of-mirrors feeling. Such pictures are striking at first. Then, on second glance, they are often disappointing, as the mind assimilates the trick—a simple trick, after all—of creating a symmetry of the large and the small.

In the real world, the simplest fractals never quite suffice to capture natural complexity. The laws of physics conspire to change some structures dramatically on the way from the small to the large. An elephant must have stout legs to stave off collapse, while a cockroach barely feels the effect of gravity. A sequoia's trunk must be more than just a scaled-up version of a flower's stem. Furthermore, nature's substance is granular; the size of molecules sets a lower limit on patterns that repeat themselves on smaller and smaller scales. Still, within limits, scientists find the laws of fractal geometry governing much of the natural world. Ferns have proved stunningly fractal. The simple branching instructions encoded in their DNA produce an orderly sequence of visual echoes, from large to small. More complex plants, too—with leaves that may be rough-edged or almond smooth, with flower petals rising above stabs of grass—can be mimicked by surprising simple fractal combinations.

The same patterns of jaggedness that give a mountain ridge its

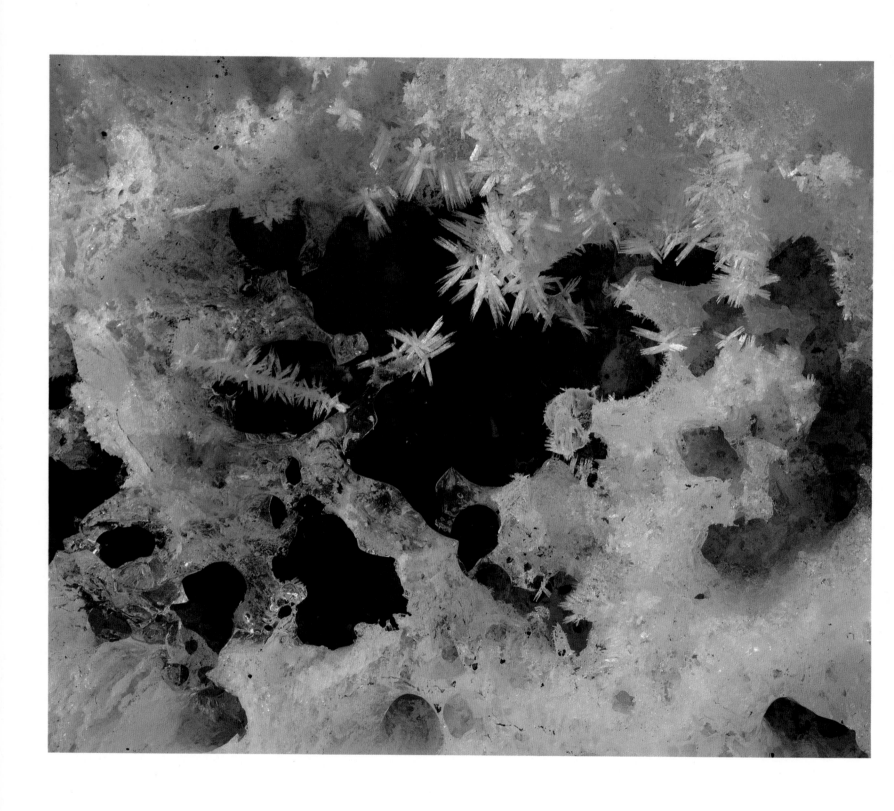

22. *Ice crystals, Black Island, McMurdo Sound, Antarctica, 17 December 1975*

characteristic shape, the same mixtures of large and small detail, appear again and again in the distribution of natural objects. They need not be structures, like mountains or trees. Fractal relationships govern the arrangement of cracks in a dried mud bed, the blotching of green lichen on a tree trunk, the clustering of galaxies, and the scattering of rocks on a talus slope. The measurements in this new mode have enormous utility for researchers. As Barnsley has put it: "Fractal geometry is a new language. Once you can speak it, you can describe the shape of a cloud as precisely as an architect can describe a house." They also reflect our intuitive sense of hidden connections. Clouds, despite their enormous variability, have proved fractal on scales up to a million square kilometers or more. A startling characteristic of such scatterings is that they undermine the notion of *average*—it becomes mathematically meaningless to speak of the size of an average raindrop or the height of an average ocean wave or the bulk of an average iceberg breaking off the Antarctic shelf. Scientists try, but they always invoke artificial cutoffs at the high and low ends, and the results always mislead. The smallest iceberg is either undefinable or invisible. The largest occurs so rarely—and so dramatically—as to confound traditional statisticians.

In the restricted cosmos of a computer or in nature's freer realm, fractals flow toward infinity in a way that the mind has trouble conceiving. How many tributaries does the Mississippi River have? How small is the smallest? How long are all the branches together? The answers to all such questions require at least a sense of the infinite. The number of branches and their total length approach infinity, just as the size of the smallest branch approaches the infinitesimal. Oddly, from the practical perspective of a river's function, this must be so, as Benoit

Mandelbrot, the mathematician who invented fractal geometry, himself pointed out. A river drains an area of the earth's surface; in some sense, its fingers must penetrate every part of that area.

Not at every instant, of course. The microscopic rivulets that feed a river appear and disappear with the rains. At its farthest edges a river's precise shape and size fluctuate dynamically with the day's rainfall or the year's wet and dry seasons, one brook appearing as another dries out. Nor is there any simple dividing line between the transient and the permanent parts of a river. Time can fill huge basins and empty them, giving desert landscapes like the American West a Martian look. Fluctuations in the river's confines affect every time scale, from the seconds of an ephemeral shower to centuries and millennia. If you could film the life of a river and replay it in fast motion, you would see a symphony of rhythms, from the bass of the great branches to the treble flickering of the tips.

The human view of nature sometimes overlooks such rhythms. When we see a river in motion, we see the flow of water, smooth in some places, broken and turbulent in others. When we watch ocean waves rolling up the incline of a sandy beach, we can be mesmerized by the surf's unpredictable pulse: offshore the swells seem to be approaching in cadence, yet when they strike they swirl first left, then right, interfering with one another or reinforcing one another, creating a rhythm that never repeats itself. Other flows escape our perception, because they are too slow or too grand in compass. A cloud floating overhead gives the illusion of a static object, simply borne from one place to the next by the wind. But it is not so. Even when a cloud looks most like frozen cotton candy, it slowly seethes and tumbles in the air. A motion picture of clouds, played ten or one hundred times too fast, always shows the wildness lurking in apparently passive formations.

A careful observer of nature, without benefit of fast-motion films, can also see the dynamics frozen in the shapes of rocks and plants. Geologists have long struggled to understand some of the stranger formations exposed where rock breaks the earth's surface: fat "fingers" of one mineral intruding in another; or layers that form not just horizontally but vertically, with thicknesses ranging from fractions of an inch to hundreds of feet. Lately geologists have begun turning to fluid dynamics. They have little choice. The precursors of their monumental rocks were fluids in motion, molten magma at high subterranean pressures, and these fluids could behave peculiarly. Instabilities arose in their motion. Boundaries bulged or twisted; odd shapes developed at the interface between two different fluids.

The contention of the new science of chaos—the motivating contention—is that such seeming irregularities can be contemplated, sorted, measured, and understood. Traditionally scientists looked for a more conventional order in nature and treated the erratic as a side issue, an unpredictable and therefore unimportant kind of marginalia. Now scientists are more willing to look directly at the irregularity. They acknowledge Mandelbrot's credo: "Clouds are not spheres, mountains are not cones, coastlines are not circles, and bark is not smooth, nor does lightning travel in a straight line." And they accept his challenge: to scrutinize, rather than dismiss, the apparently formless; "to investigate the morphology of the amorphous."

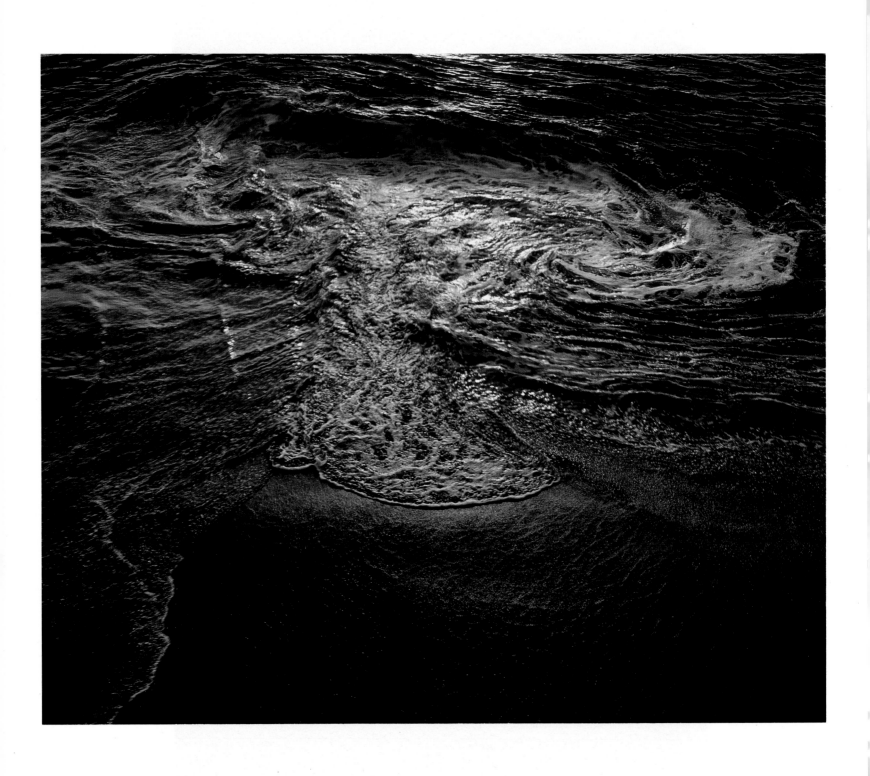

Surf, Buccaneer Cove, Galápagos Islands, 9 May 1966 26.

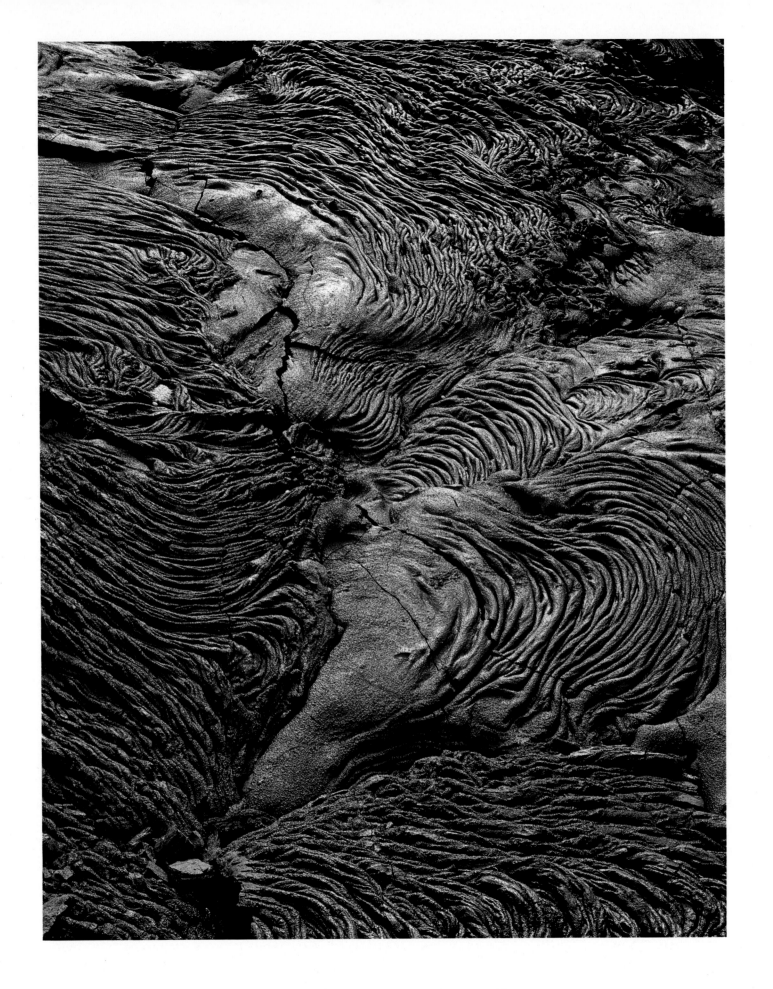

Lava flow, Sullivan Bay, James Island, Galápagos Islands, 10 March 1966

29.

Structure implies history. History infiltrates and inspires any solid form, even one as seemingly shapeless and ephemeral as an assortment of grasses strewn like pickup sticks on a meadow's floor. The past of a rock wall—the stable and unstable flows, the crystallization and the pressure that shaped it—reverberates in its visible layers and cracks. Gnarled shoulders of black lava reveal one sort of past. Other sorts may be harder to read: the history of dynamical and chemical changes in molten rock that lead one mineral to condense, another to crystallize.

Part of the movement toward understanding chaos has been an appreciation of pattern formation as a specialty in its own right. The laws of pattern formation seem to govern snowflakes as well as microscopic crystals in metal alloys, the banding of underground gneiss as well as the slow diffusion of lichen across a rock surface. Theoretical physicists are analyzing the delicate tension between order and disorder that creates such structures. There is a hierarchy of patterns, from small to large, that seems equally familiar to those studying the organization of computer networks or human societies. "All structures (whether of atoms, cells, philosophies, or societies) began from something that was without form and void," Cyril Stanley Smith, a metallurgist and an expert on structure, has said. "A nucleus of a definite structure somehow formed somewhere, and if it was a structure more desirable than chaos, it then proceeded to grow at the expense of chaos. . . ."

A snowflake begins with a nucleus. A seed of ice imposes its order on the molecules nearby. Crystallization requires molecules to snap into alignment, forming the rows and facets along which a solid may later cleave. The substance communicates its order not just over the short range, neighbor influencing neighbor, but over long distances, almost mysteriously, creating patterns that echo one another on scales of hun-

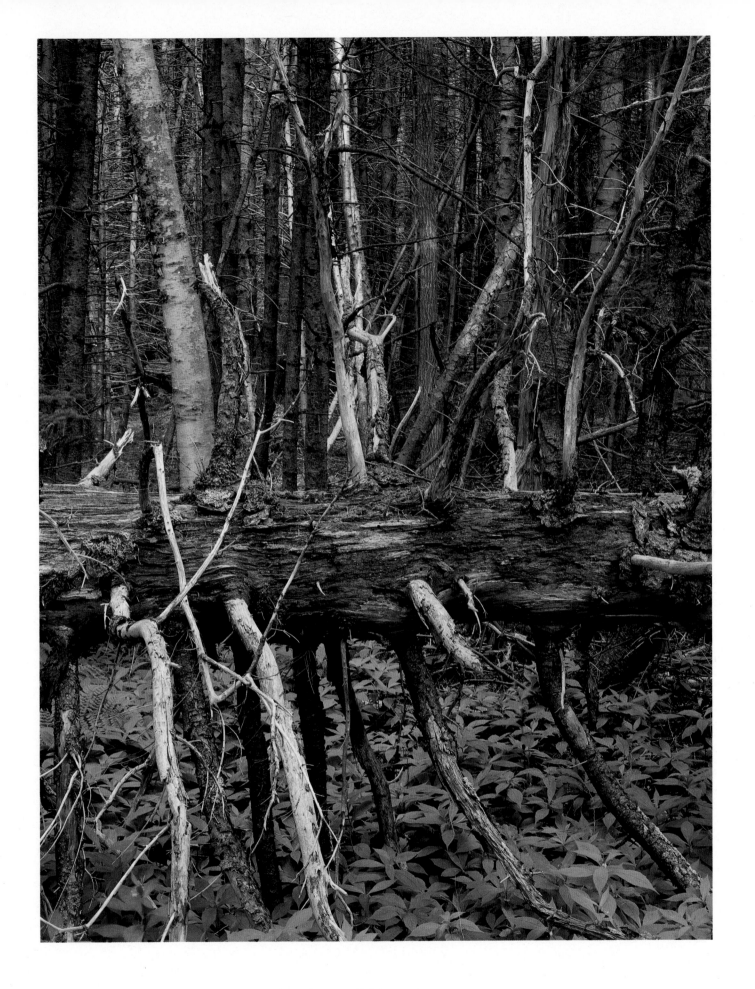

Fallen tree, Great Spruce Head Island, Maine, 21 July 1974

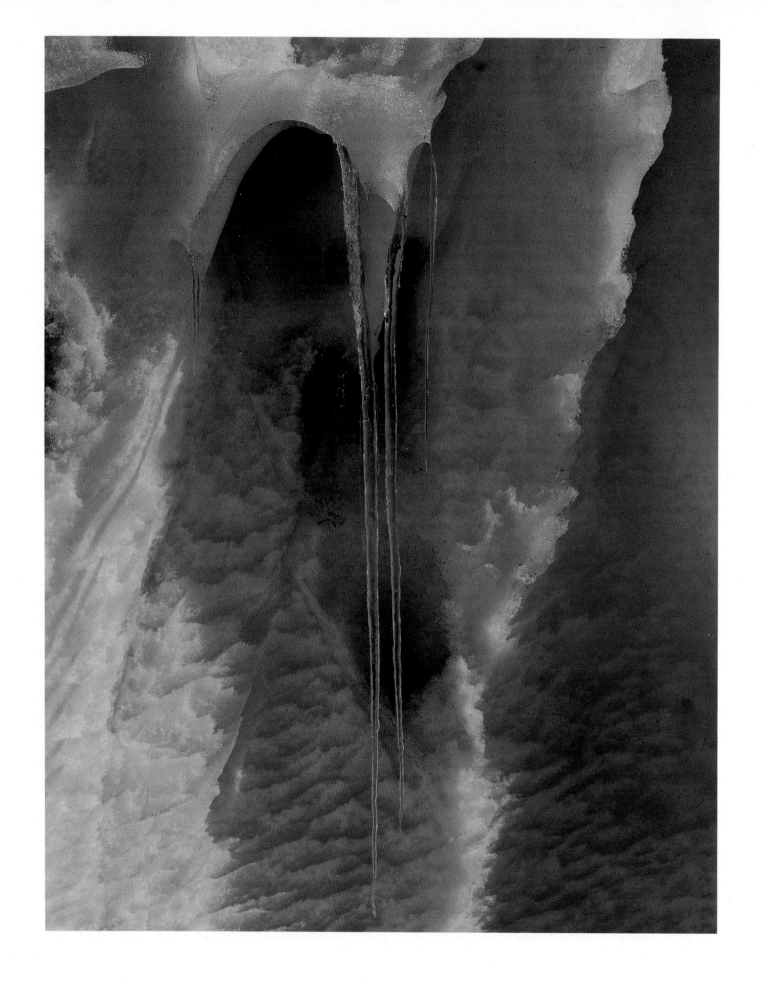

32. *Icicle, Koettlitz Glacier, McMurdo Sound, Antarctica, 17 December 1975*

dreds or millions of atoms. Defects and misalignments break up the simple geometry. Ice crystals grow as dendrites, swordlike structures, the points branching and forming new needles. A complex shape arises out of a featureless void. If a sixfold symmetry becomes visible to the naked eye, the water molecule has imposed a simple order on the whole. But the perfectly symmetrical snowflake of the standard rendering—of the schoolroom paper cutout or the textbook illustration—occurs rarely in nature.

A snowflake does not form instantaneously, but grows, its progress controlled by the diffusion of heat away from the center. The freezing releases heat at the boundary between solid and liquid, and the heat must ebb away. As the boundary moves, it wrinkles and breaks up. The surface is unstable. As any piece of the boundary pulls ahead of the rest, it gains an advantage in grabbing new water molecules. It becomes a bulge, then a point. If enough space opens up, it may wrinkle and branch again. A flash of lightning through stormy, electrified air branches in the same way; a fern on a dank forest floor, in the same way. Though the materials, the timing, the physical details are all different, some mathematical core must be shared.

Every so often, a television weather announcer reports that scientists—generally amid a "flurry of excitement"—have found two identical snowflakes. It is never true. The possibilities of this canonical form seem never to end. Snowflakes are born in chaos. The delicate balance between order and disorder: in a growing ice crystal, diffusion pushes toward instability, breaking up the boundary; the contrary force of surface tension tries to smooth it again, make an even skin like a soap bubble's. A competition emerges, one force trying to sharpen the crystal, another trying to flatten it. Like living organisms, the snow-

flake at once seeks and abhors an equilibrium. And all the while, this crystal, one object growing among millions in a storm, falls slowly downward through a turbulent wind.

Energy ebbs away, yet structure emerges. In creating a snowflake nature surely violates the spirit, if not the letter, of the Second Law of Thermodynamics. It is the Second Law that says the cosmos is winding down, entropy always increases, the universe and any closed system within it have an inexorable tendency toward disorder. To create order, one must expend energy. The energy must be borrowed from somewhere else. If a fern spreads its special kind of order, sprouting yellow branches across a forest floor or a crevice of lava, it has presumably drained its orderliness from the sunlight that penetrated the shadows. Thus the universe slowly winds down. Its balance sheet cannot be cheated. It heads toward a final, featureless heat bath of maximum entropy—this, anyway, is the fate implied by the Second Law.

As a rule of thermodynamics, the Second Law is undeniable. As a guide to organization and disorganization in nature, it seems to fail. Few scientific subjects so confound specialists with problems of definition. Order, Disorder, Entropy, Randomness—these words are notorious traps. Even the most random-seeming of the earth's images—the cracks, large or small, that appear in drying mud beds, or the rocks that drift helter-skelter across a mountain's slope—distribute themselves according to laws that subtly organize the relation of large things to small. Whether the subtly shaped and misshapen needles of an ice crystal are more or less orderly than a cube from a refrigerator ice tray is, at best, not obvious. Still, structure emerges.

Entropy's worst enemy is life itself. Lichen spreads across an exposed rock, sending out tendrils or fingers. This is primitive, pioneer

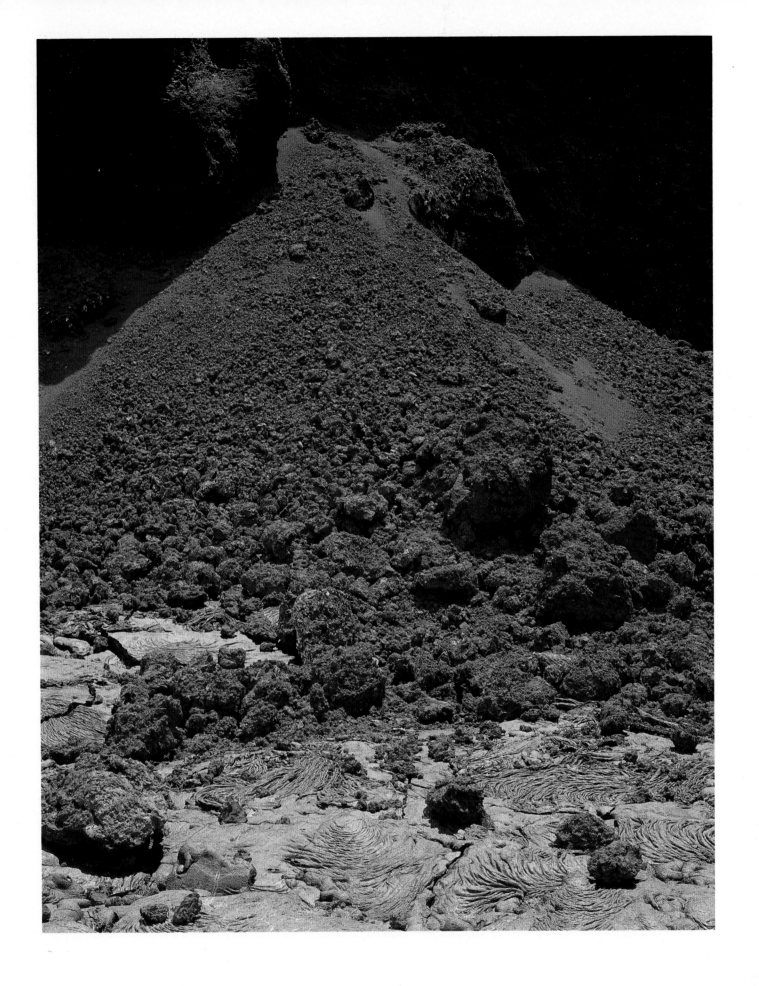

Lava and ash talus, Sullivan Bay, James Island, Galápagos Islands, 10 March 1966

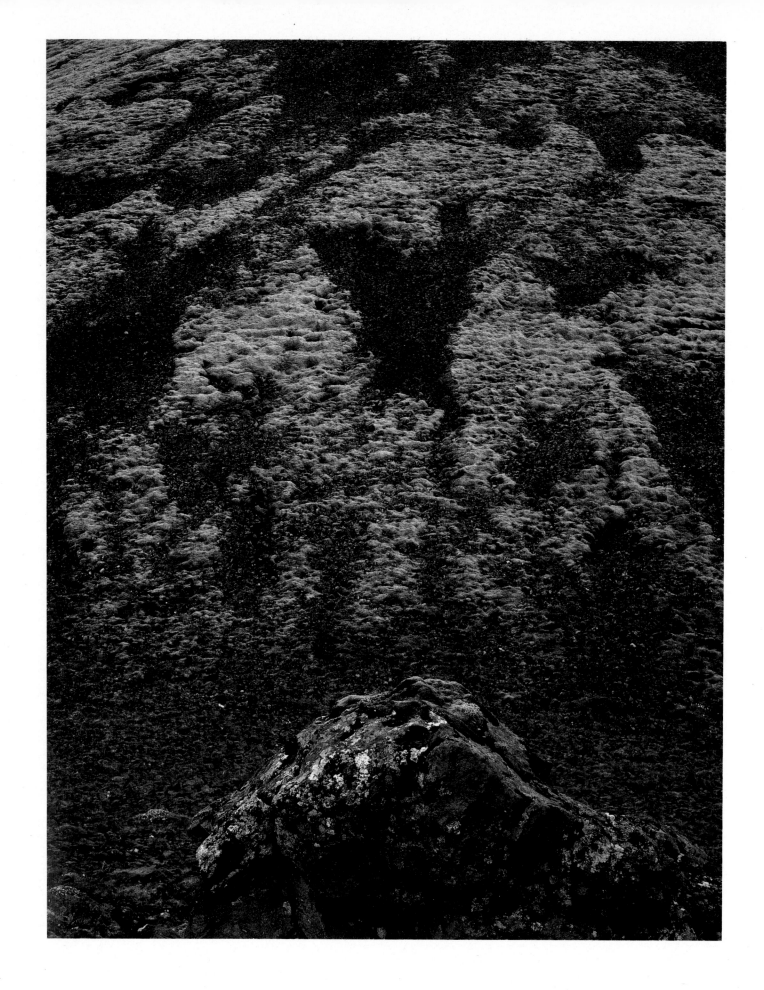

36. *Moss on talus, near Laugarvatn, Iceland, 25 June 1972*

life, barely more complicated than the most basic blue-green algae. But it, too, draws an irregular order from pure disorder. With acid it etches itself into the mineral over centuries, holding its place against the wind. It creates dusts, spots, miniature islands and continents on a rock face, or hangs from trees in beardlike fronds. In death—an organism's personal version of maximum entropy—the complex lacework of such vegetation begins once again to unravel. Dried wind-strewn grasses, leaves crumbling into the soil—the patterns slowly fade again into the background.

The human mind is a powerful pattern-recognition machine, more powerful than any computer yet built. Sometimes it is too powerful; it detects patterns where they do not really exist. Experts "see" a whole menagerie of too-simple patterns in stock-price graphs, head-and-shoulders patterns, or patterns based on spirals and pyramids. Compelling, too, when we observe nature, is our sense of orderly form hiding just out of our clear sight, within the multitude of impressions that the world offers. There is grist for cranks here. One timeworn way to find a spurious order in nature is to search for certain familiar proportions. One measures leaves, fishes, and butterflies and finds "rhythms"—the golden mean or other harmonious ratio. One finds them, because one cannot fail to find them. Given the infinite variety of leaf lengths and widths, any desired ratio appears reasonably often. Still, leaves are not infinitely various in their shapes. Far from it—the basic shape is clear. The blade may be smooth or toothed, rounded or elongated; the veins may branch more or less intricately; but the universality of a leaf lies in its form, not its proportions.

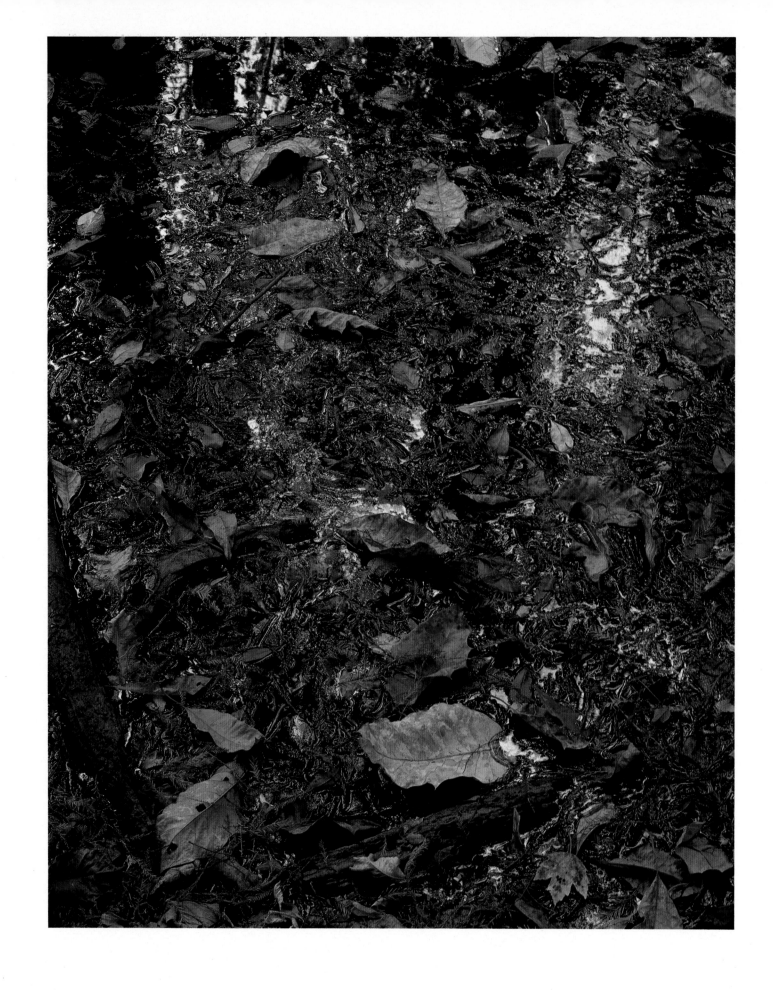

38. *Fallen leaves on water, Congaree, South Carolina, 25 October 1969*

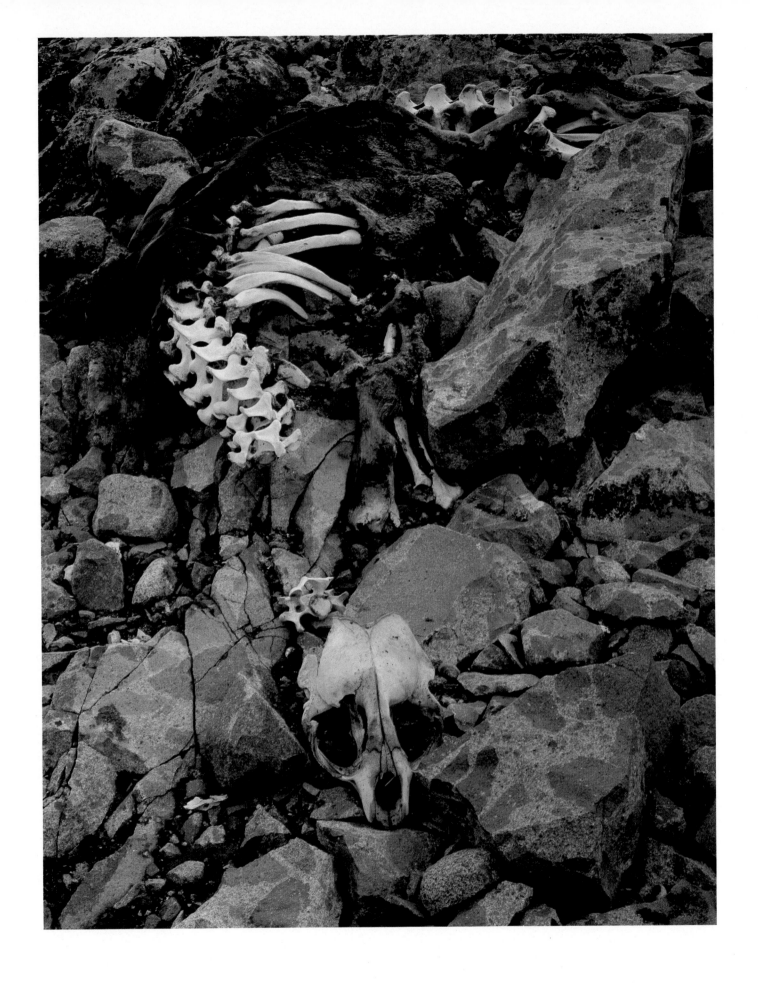

Weddell seal skeleton, Prospect Point, Antarctica, 6 March 1976

Given a random scattering of dots, the eye often sees groupings and clusters that mean nothing. Yet a random scattering of dots is not so easy to come by. To put one on a computer screen requires—if one insists on honest randomness—serious mathematical sophistication. Nature itself rarely produces anything that qualifies. With the simplest of tools and the bluntest of processes, nature repeatedly builds highly nonrandom forms. "Nature does not premeditate," as Peter S. Stevens has put it, "she does not use mathematics; she does not deliberately produce whole patterns; she lets whole patterns produce themselves. Nature does what nature demands; she is beyond blame and responsibility."

Ask a scientist how birds flock or how fish school. Not why (assume, say, that evolution has favored the safety-in-numbers principle as a defense against predators) but how—how do ten thousand shore birds suddenly rise into the air, coalesce into a graceful formation, and wheel about, as if directed by a single mind? Nothing in the motion of an individual bird or fish, no matter how fluid, can prepare us for the sight of a skyful of starlings pivoting over a cornfield, or a million minnows snapping into a tight, polarized array.

When a predator approaches, a flock can execute turning maneuvers with a speed that has baffled scientists. High-speed film reveals that the turning motion travels through the flock as a wave, passing from bird to bird in the space of about one-seventieth of a second. That is far less than a bird's reaction time. Some zoologists have quite seriously proposed in technical articles that there must be some mechanism of "thought transference" or some undiscovered means of "electromagnetic communication." They have generally assumed that some bird or birds must be acting as leader.

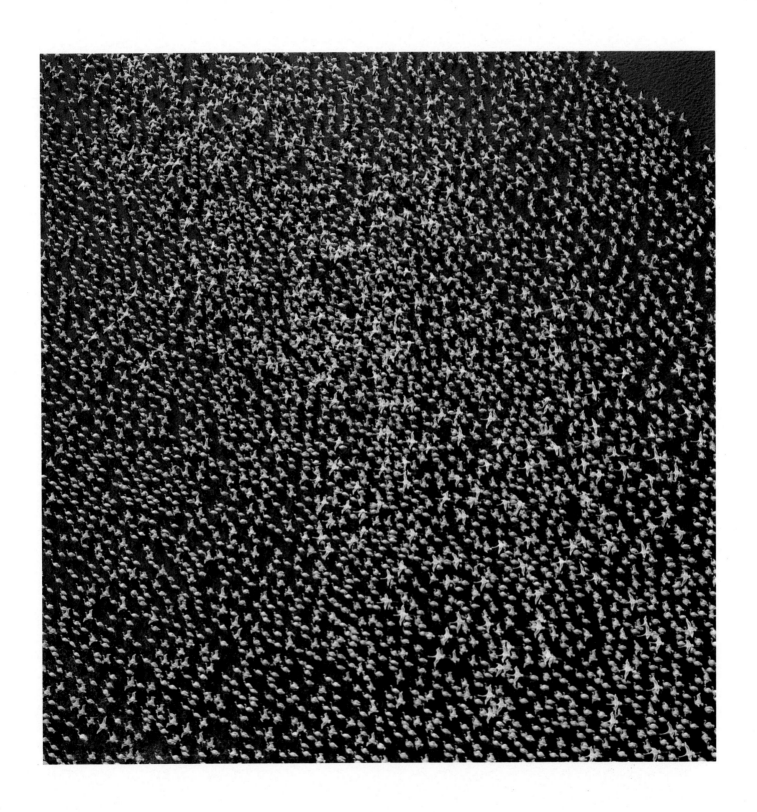

Flamingos on Lake Natron, Tanzania, Africa, 1970

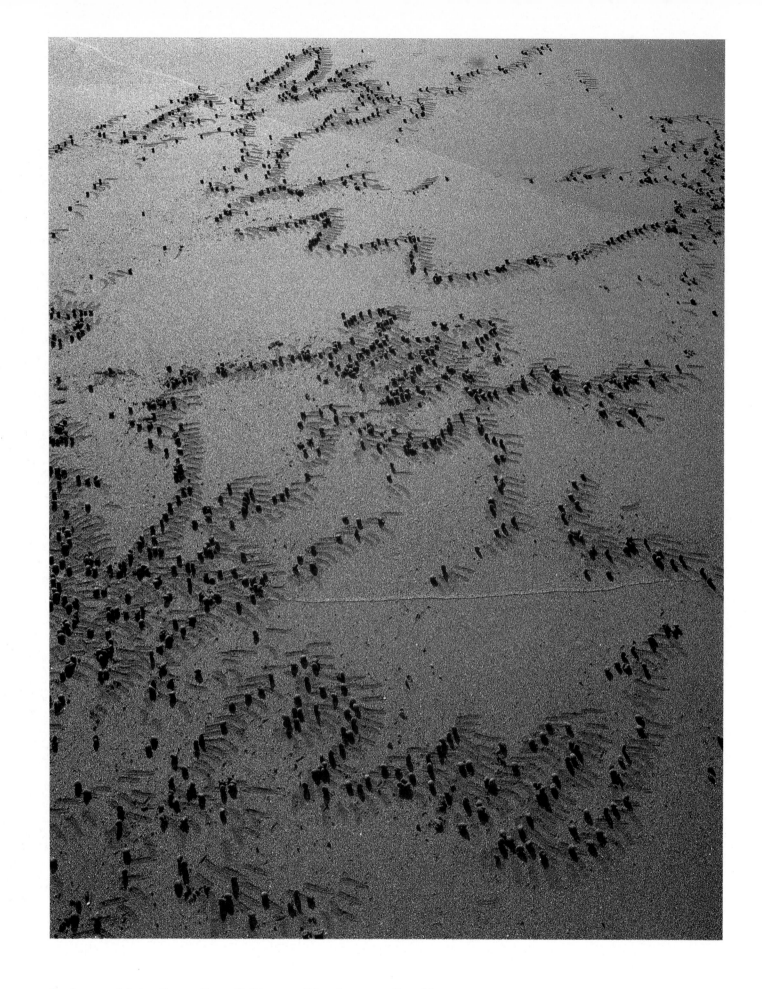

42. *Crab scratchings, James Bay, Galápagos Islands, 1 April 1966*

That no longer seems to be so. The study of chaos has provided a seemingly paradoxical insight: that rich kinds of order, as well as chaos, can arise—arise spontaneously—from the unplanned interaction of many simple things. Cooperation arises in nature, or the illusion of cooperation, not just in animate beings but in the inanimate as well. The results are hypnotic. "They form patterns and the patterns entrain our brain," as one zoologist, William M. Hamner, has said. "We like patterns—we like patterns in waves, and we like patterns in a fire, and we see a flock of birds in the sky and we see a pattern in the overall movement. That's the beauty of the whole system, but it's also the thing that screws up human investigators."

Like people forming complex cross patterns of foot traffic through a public space, or crabs etching pathways in the sand, flocks and schools make designs that the group's members cannot see. Compared to land-bound species, the birds and fish have the advantage of a third, spatial dimension. And it is hard for investigators to resist the sense of purposefulness. If purpose cannot plausibly be attributed to a flamingo, or a thousand flamingos, the framework of evolutionary theory often provides a longer-term sort of purpose.

As chaos theory alters the preconceptions of a variety of sciences, the understanding of flocking and schooling has begun to change. Some researchers have now abandoned the search for an individual leader and for a special means of communication. Instead, they have accepted the possibility that such complex group-scale behavior can emerge spontaneously out of the interactions of simple individuals behaving according to simple rules. Computer simulations have produced lifelike flock behavior. The behavior is not programmed from the top down; rather, a few dozen simulated birds are given guidelines. Each flies in a certain

general direction; each tries to stay fairly close to its neighbors, but not too close; each knows to swerve to avoid obstacles. And as if by magic, the dumb brutes within the computer give birth to the cooperative grace of a natural flock.

Scales change, patterns change again. By seeing the forms that repeat themselves on large and small scales, scientists have deepened their understanding of the patterns that fail to repeat themselves—the kinds of organization that can emerge only at the top of some critical mass of underlying complexity. Particle physicists sweat to predict the behavior of a handful of subatomic jots, smashed together by accelerators. The laws they find make possible the higher-level laws studied by chemists, whose units are molecules with a handful of atoms. Yet chemists and biologists and economists, on up the scale of complexity, can profitably ignore the findings of particle physics; they have vanished, just as the behaviors of individual birds vanish when one focuses on the fluid motion of the flock. Even now it is a hard lesson to appreciate. Experts debate whether intelligence can exist in a machine whose tiniest low-level components are mindless logic circuits: on-off, yes-no, limited to the precision of a hard mathematics. Our imaginations can hardly comprehend the many levels of interaction that must build up, one atop another, to rise from the electrochemical interactions of neurons to the high abstractions of thought, music, and desire. As in a bird flock or an ant colony, the more complex patterns of organization do not really depend on the individual components. If machine intelligence can exist, it will surely not be programmed, in detail and from the top down. Already, in some of the computer networks that sprawl, with

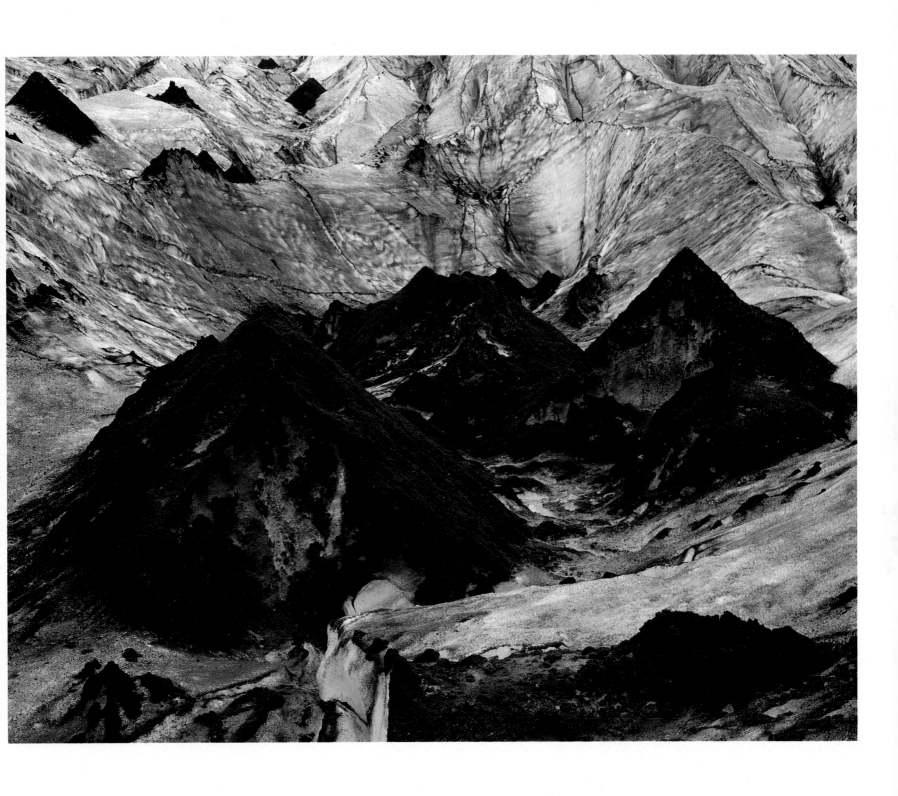

Cinders on glacier, near Skógar, Iceland, 5 July 1972

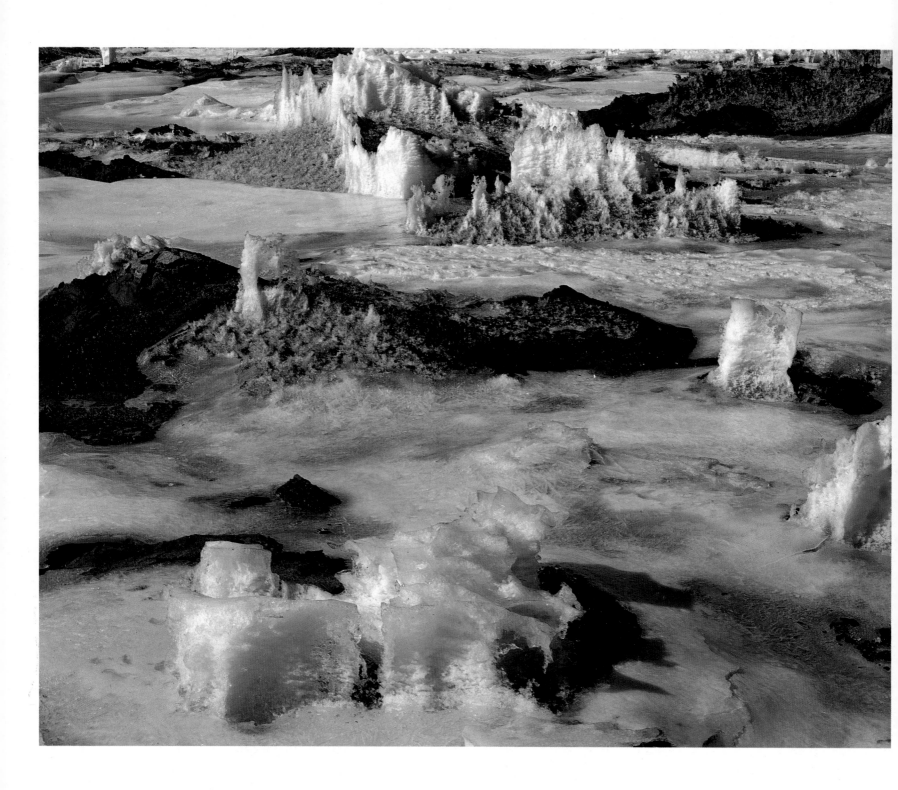

46. *Ice and sand in New Harbor, edge of McMurdo Sound, Antarctica, 8 December 1975*

many thousands of nodes, across the electronic landscape, unruly and unplanned behaviors have been observed, though no one can say what, precisely, is behaving.

Sometimes people try to create miniature ecosystems, mimicking on a smaller scale what the earth has created on a grand one. One experiment in the American Southwest has brought thousands of species together in a domed world. Simultaneously, the national park system is learning a hard lesson. To support a single large mammal, a cougar or grizzly bear, nature requires hundreds of square miles of an intricate mesh of smaller species. To support a whole, thriving population of such animals, the better part of a continent may be necessary. Even the great national parks, it now seems, cannot sustain them. The populations are dwindling and vanishing. A stripped-down ecology may be no more plausible than a poet with a brain of a mere million bits. Our imaginations may have been beggared by the monumental built-up hierarchies required to create the apparently simple manifestation of one herd of buffalo, one stand of dogwood.

We see nature in glimpses, even as we live within it. Eliot Porter's still pictures, freezing time and change, show more of the hierarchy than comes into our usual view. They connect the turbulent stresses within the wood of a tree to the turbulent motion of waves; they bond the smallest eccentricities to the largest. Scientists, too, have begun seeing these links more clearly. Their perceptions, too—their attitudes and their theories of nature—sometimes change in ways that can only be glimpsed on the wing. A great mathematician and a great physicist once sat outdoors atop a New Mexico plateau, discussing the way theories change, sometimes dramatically and sometimes invisibly. Abstracted, the mathematician watched a few puffs of white cloud drift-

ing steadily—or were they slowly tumbling?—in the blue desert sky. The physicist must have read his mind, because suddenly he said: "It is really like the shape of clouds. As one watches them they don't seem to change, but if you look back a minute later, it is all very different."

JAMES GLEICK

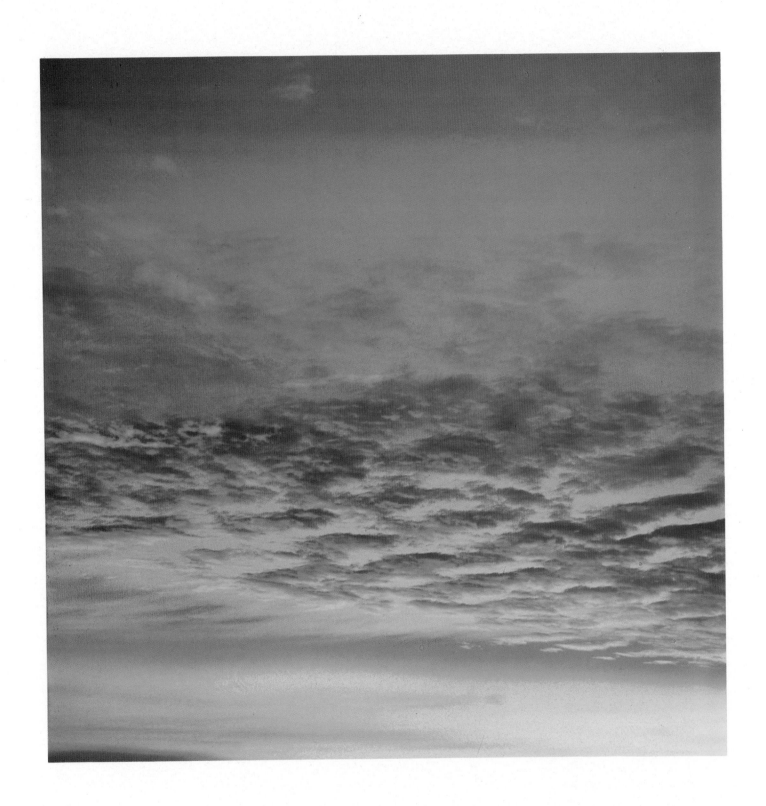

Sunset clouds, Palmer Station, Antarctica, 18 February 1976

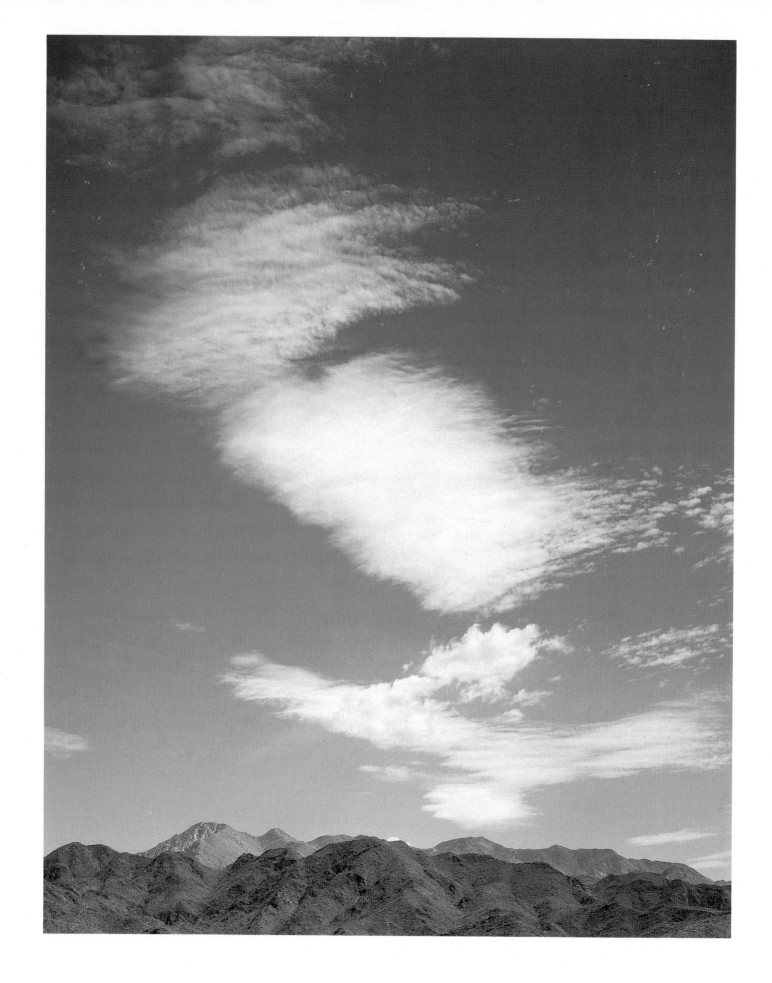

50. *Clouds over mountains, near Los Angeles Bay, Baja, California, 2 August 1966*

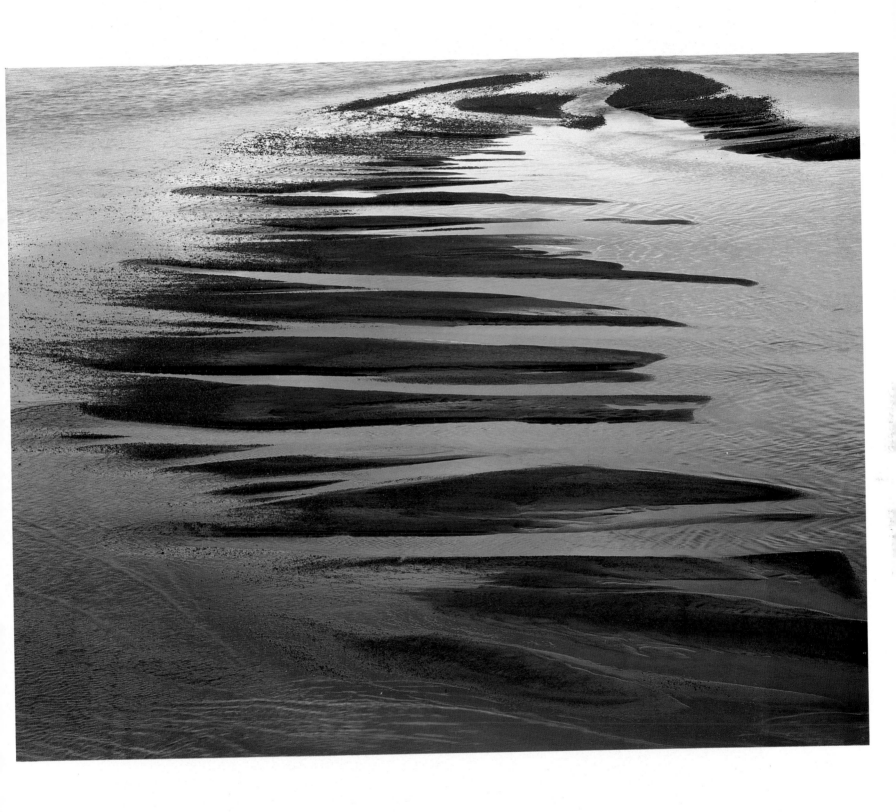

. . . fractals flow toward infinity in a way that the mind has trouble conceiving.

Sandbars in river, from Flaajokull, South Coast, Iceland, 5 August 1972

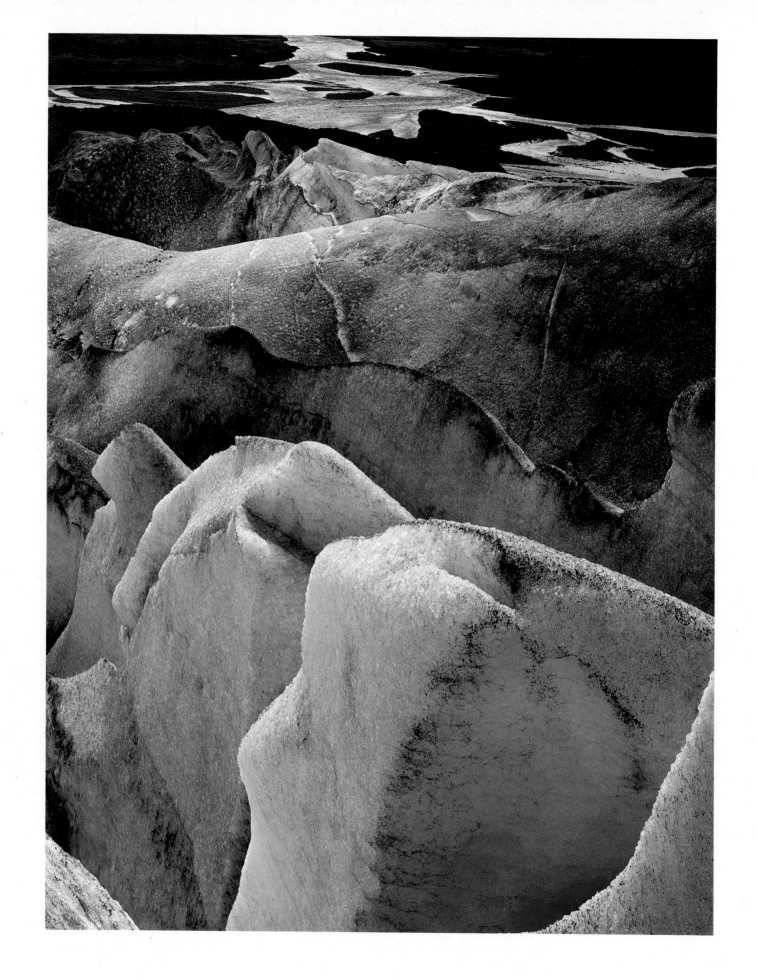

Crevasses, glacier tongue, South Coast, Iceland, 31 July 1972

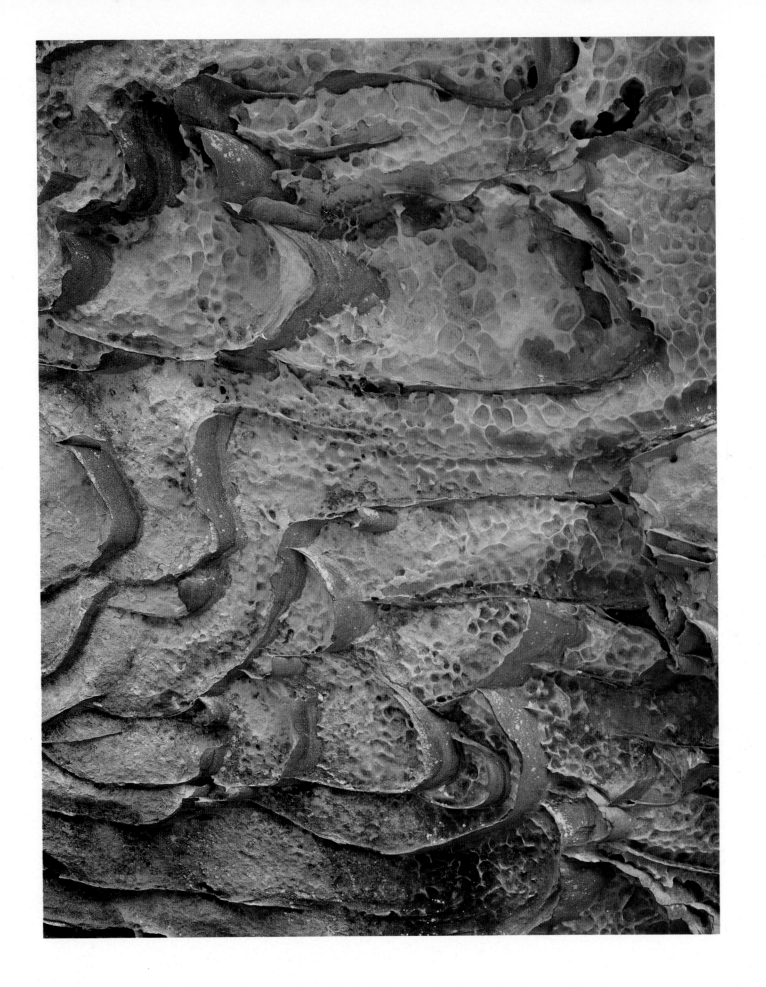

Hard inclusions in sandstone, Gray's Arch, Red River Gorge, Kentucky, 18 April 1968

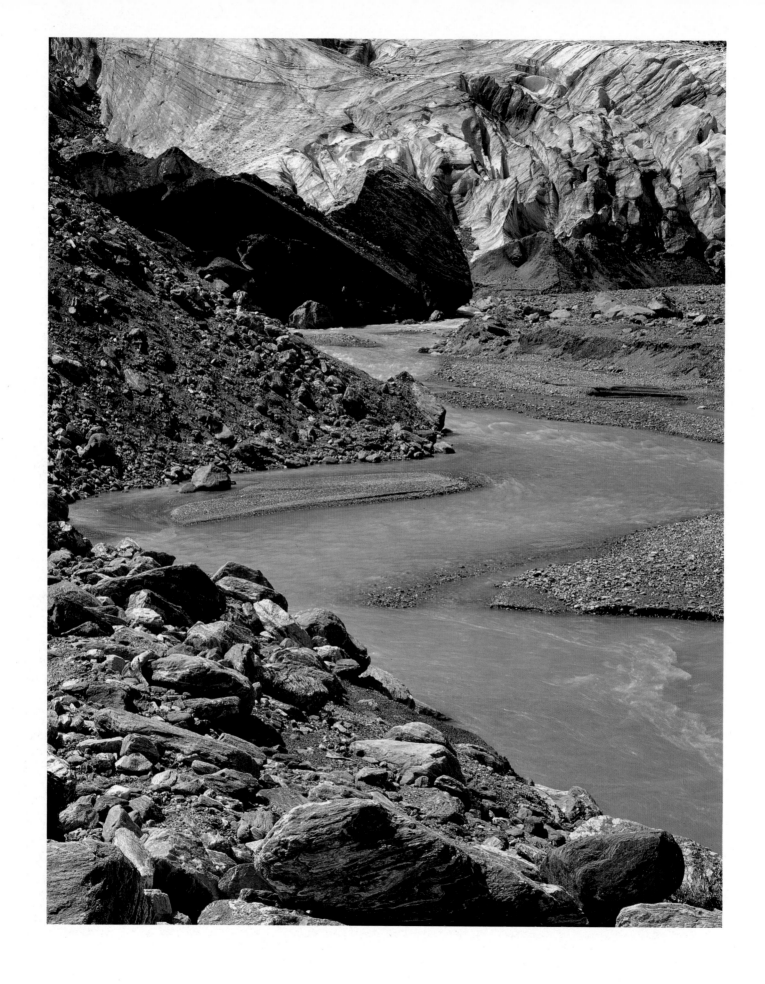

Fox Glacier runoff, New Zealand, 21 November 1975

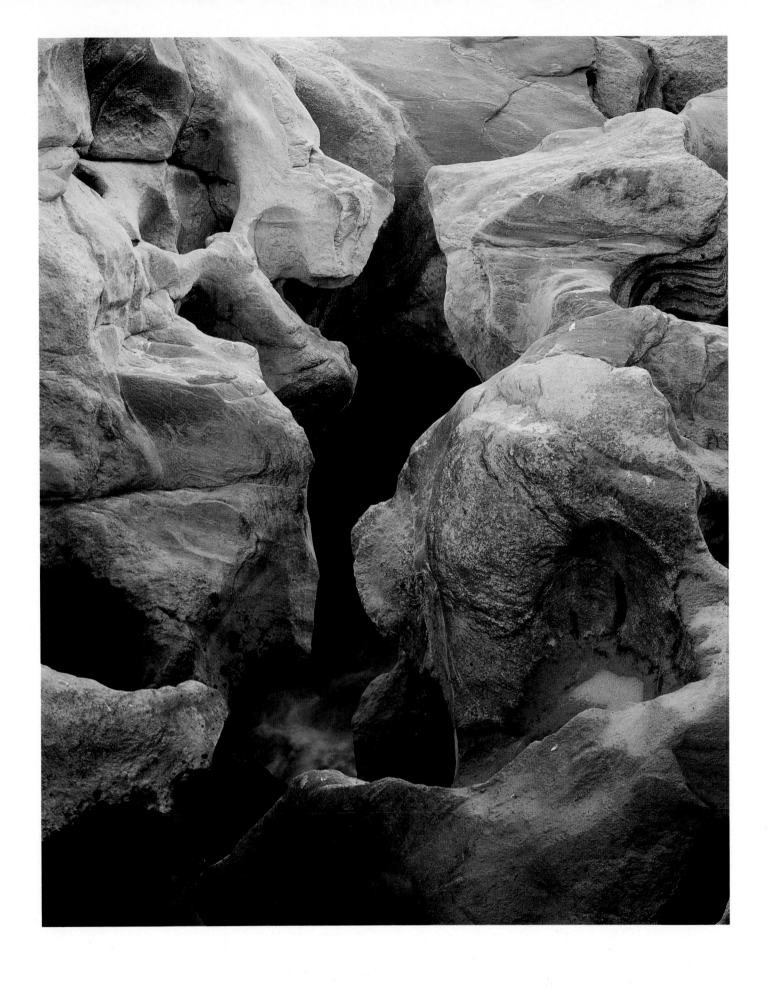

Chasm below Lugard Falls, Tsavo East, Kenya, Africa, 20 October 1970

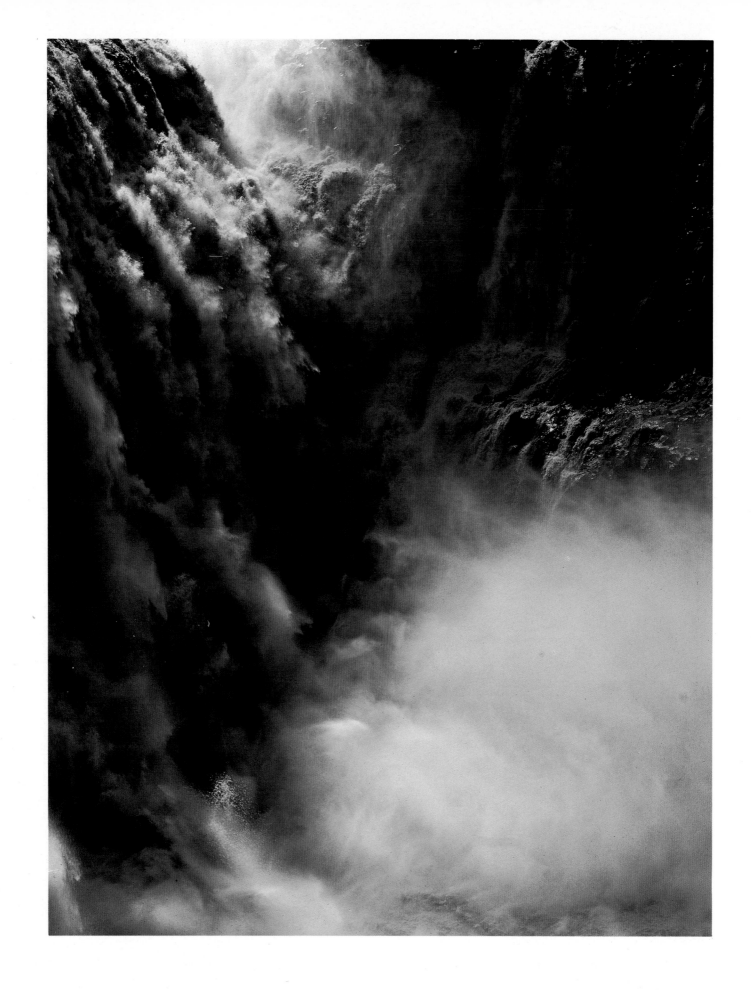

56. *Dettifoss, Iceland, 24 July 1972*

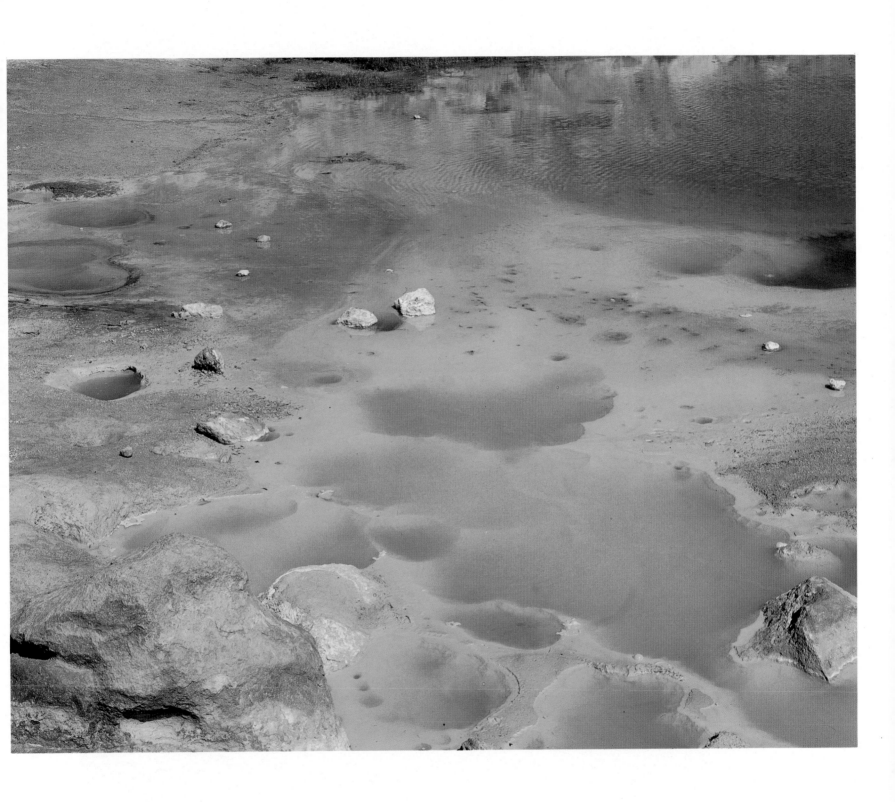

Hot spring basin, Lassen Volcanic National Park, California, 9 August 1975

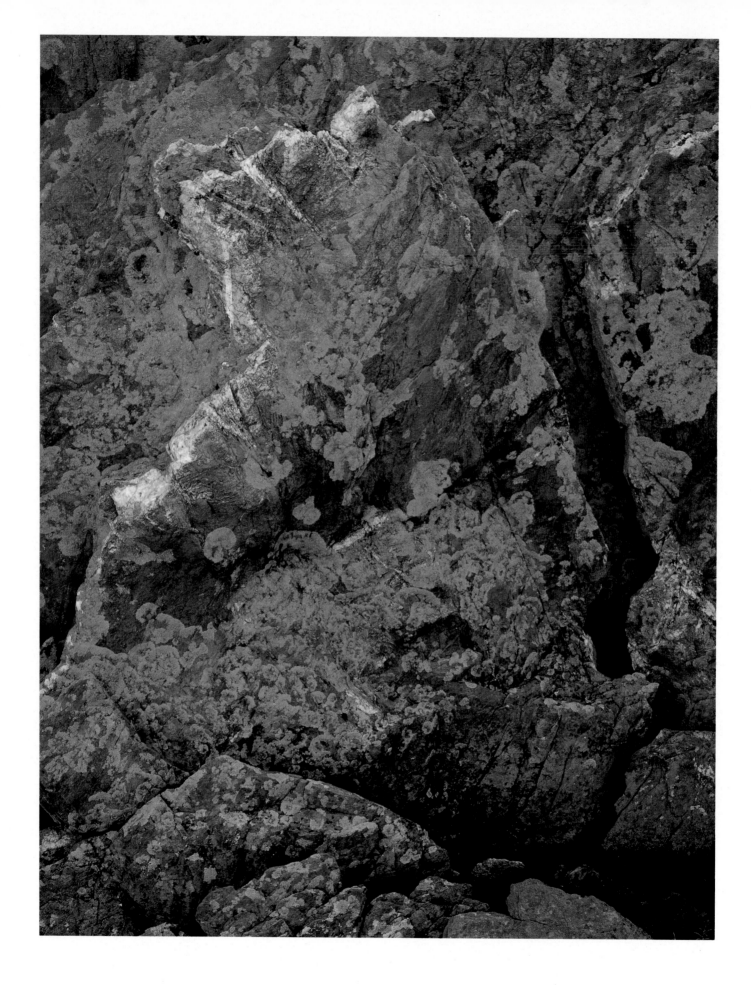

58. *Orange lichens on shore rocks, Little Spruce Head Island, Maine, 28 August 1974*

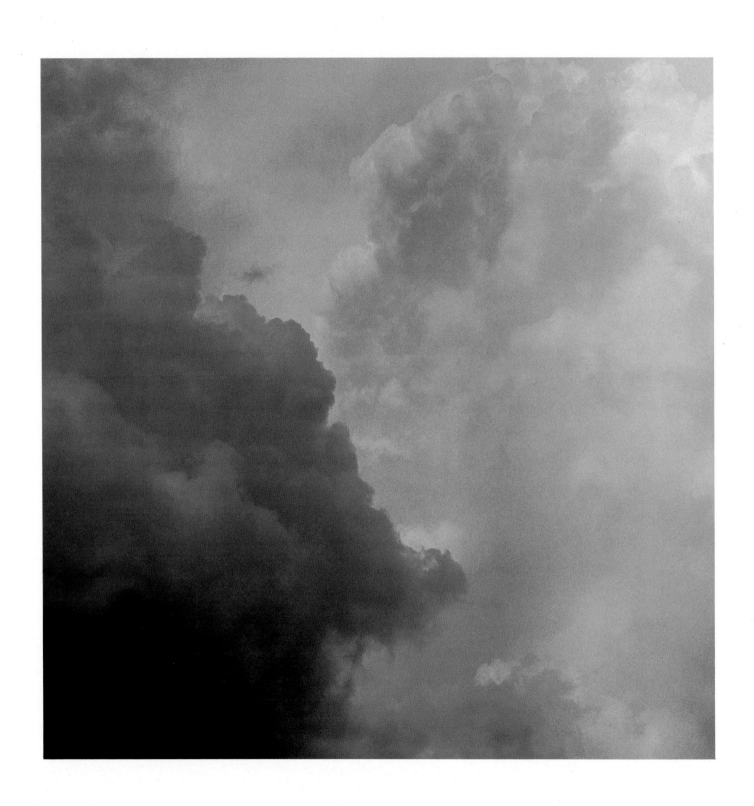

Other flows escape our perception because they are too slow or too grand in compass.

Cloud formations, Tesuque, New Mexico, August 1964

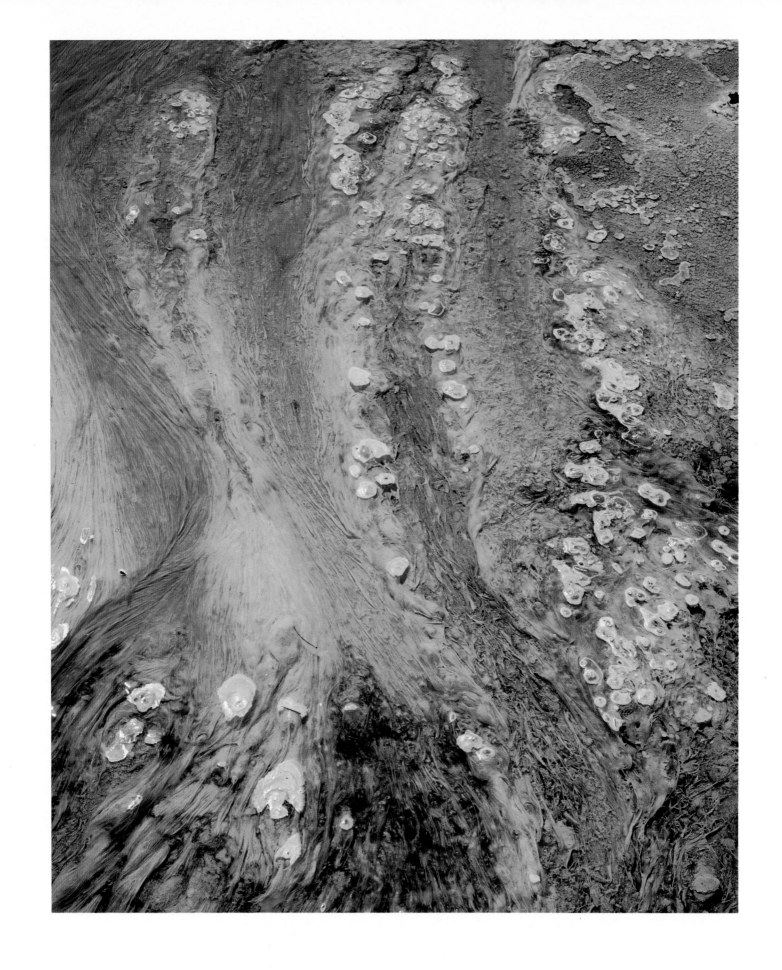

Scum and algae, Mammoth Hot Springs, Yellowstone National Park, Wyoming,
18 August 1952

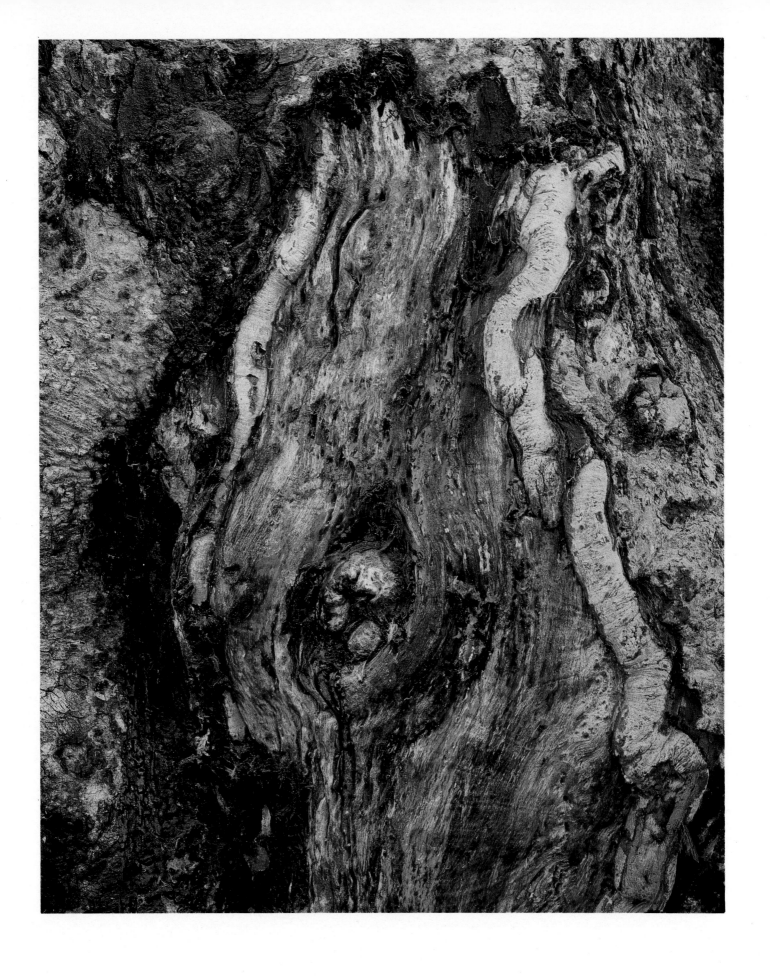

Detail, scarred bark of fever tree, Amboseli, Kenya, Africa, 16 September 1970

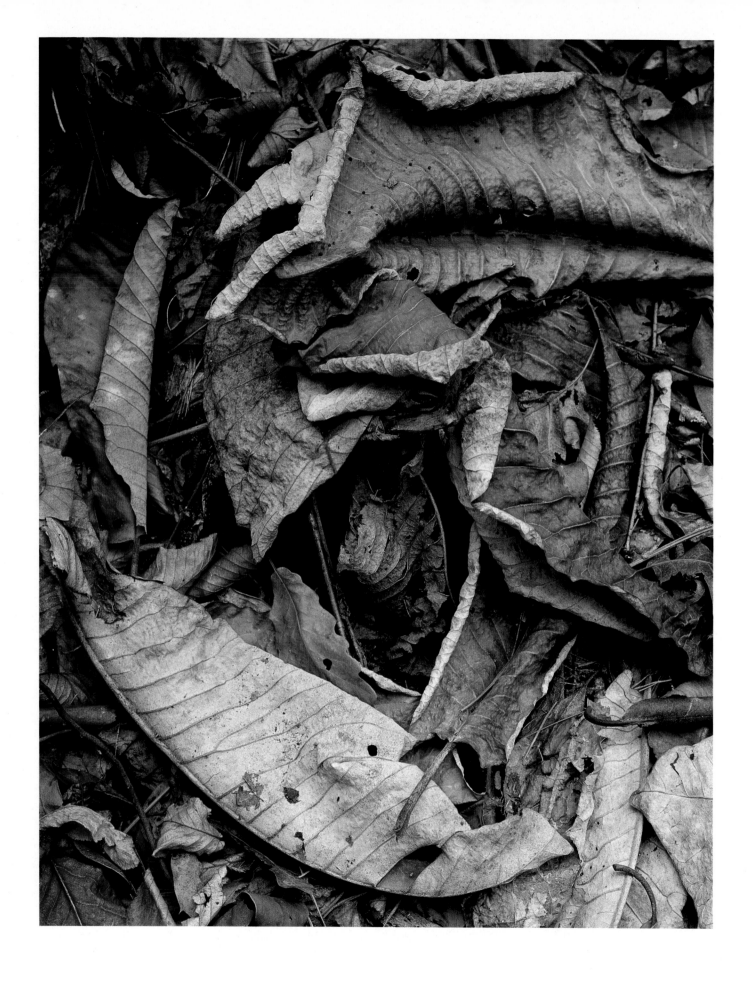

62.　　　*Dead leaves, Swift Camp Creek, Red River Gorge, Kentucky, 19 April 1968*

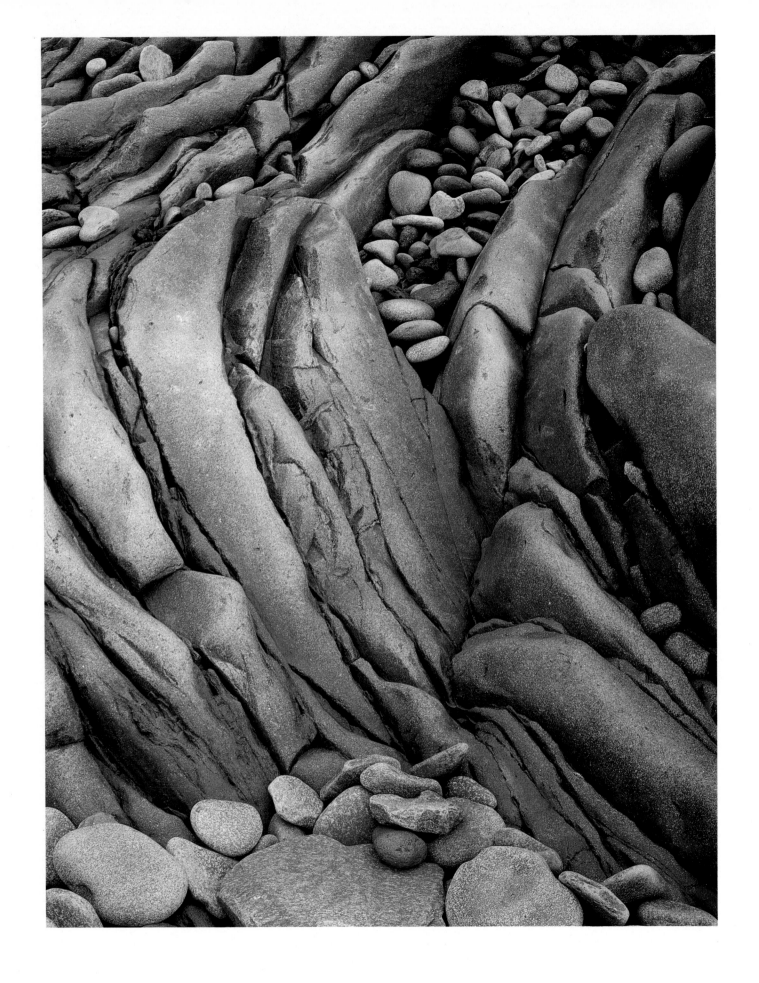

Wave-worn rock, Hellnar, Snaefellsnes, Iceland, 14 July 1972

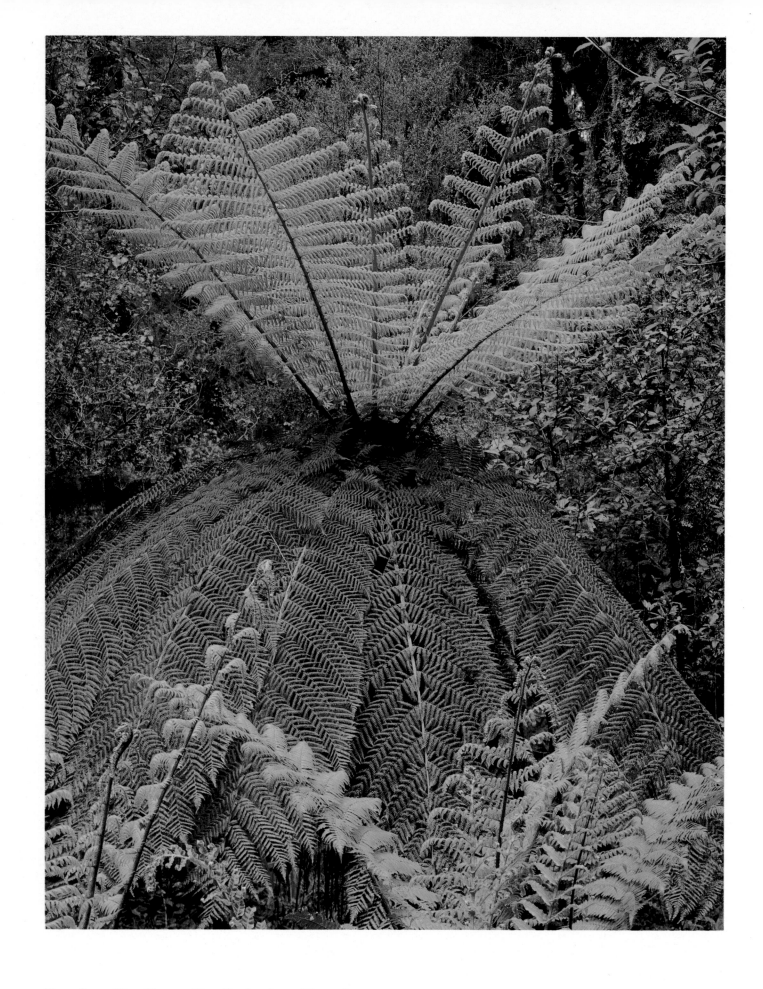

64. *Tree fern, The Chasm, New Zealand, 25 November 1975*

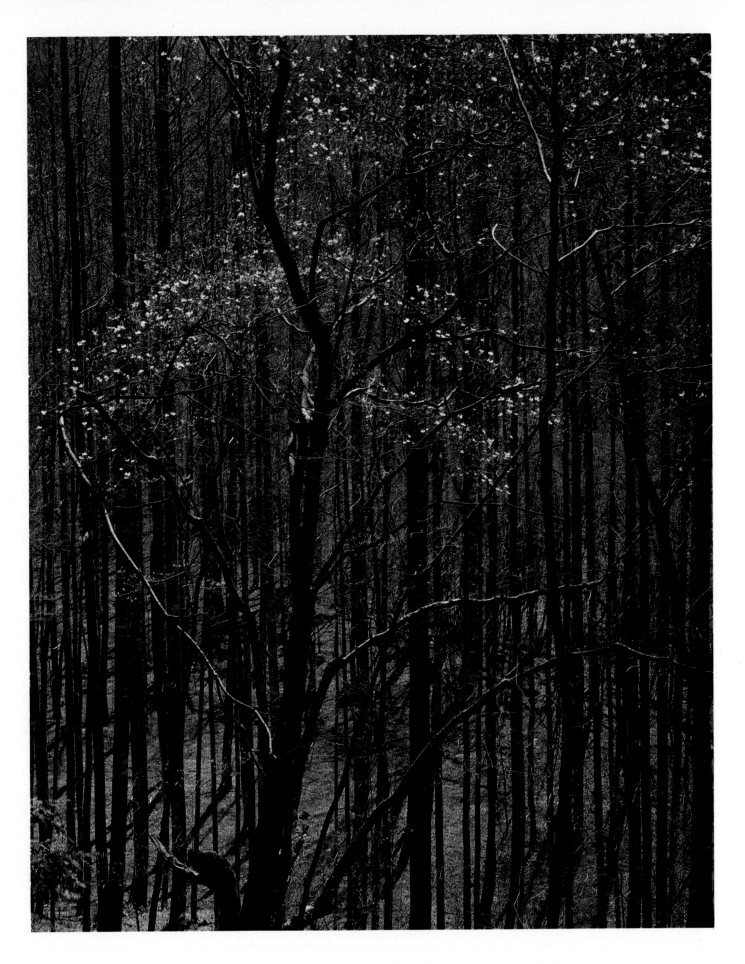

Dogwood and tree trunks, Great Smoky Mountains National Park, Tennessee,
11 April 1968

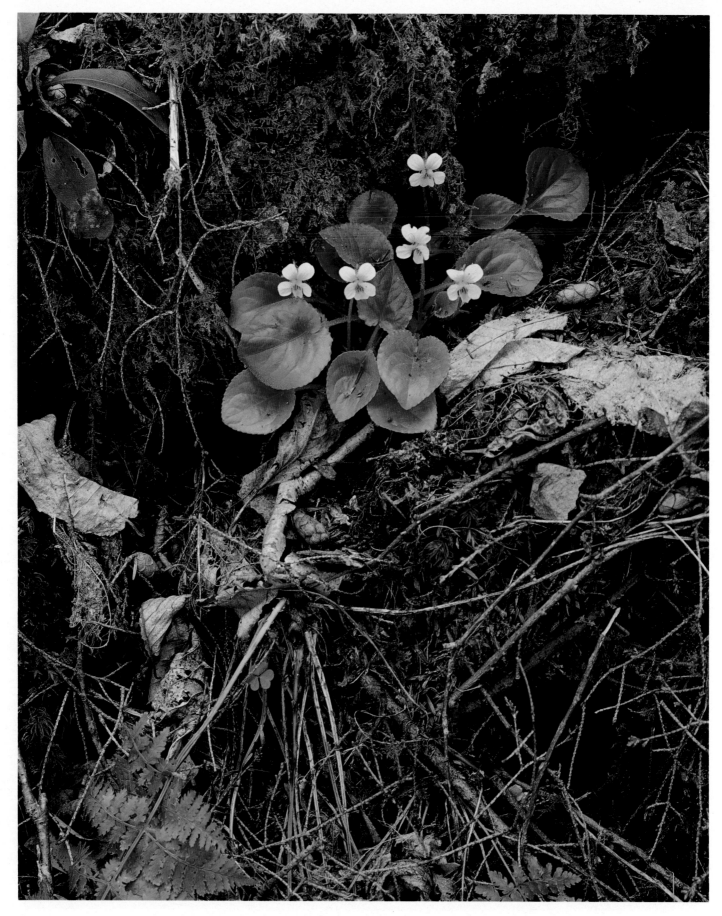

. . . nature's own symmetry, a symmetry of textures, in which the large mirrors the small.

Yellow violets, Great Smoky Mountains National Park, 12 April 1968

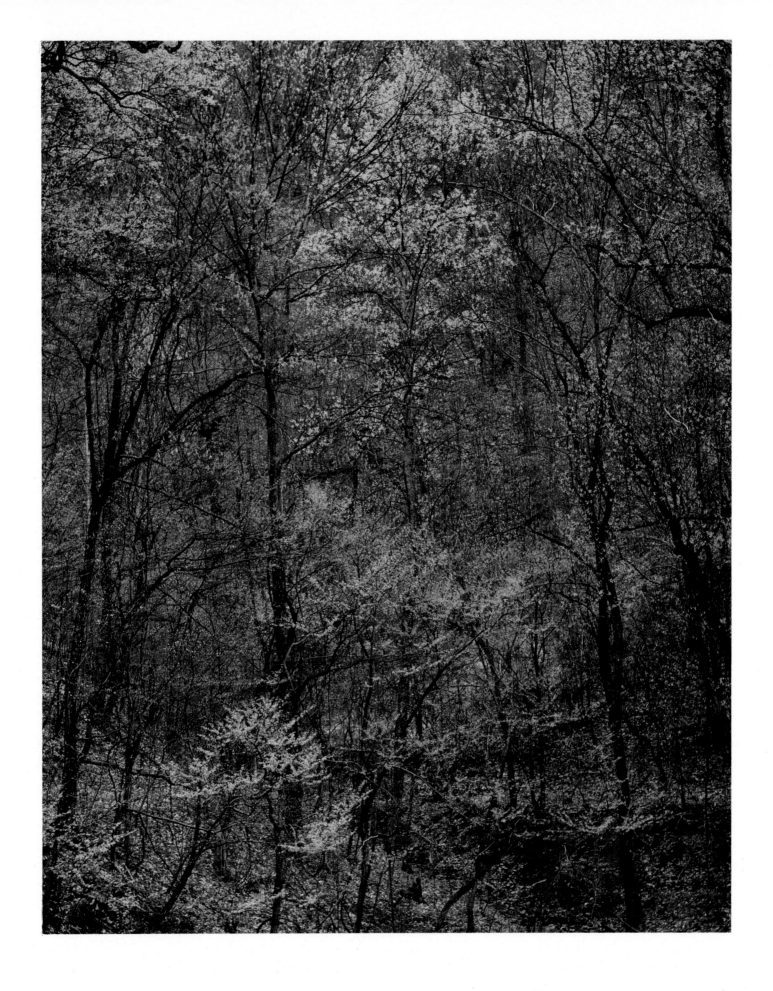

Redbud and Tulip Poplar, Great Smoky Mountains National Park, 9 April 1968

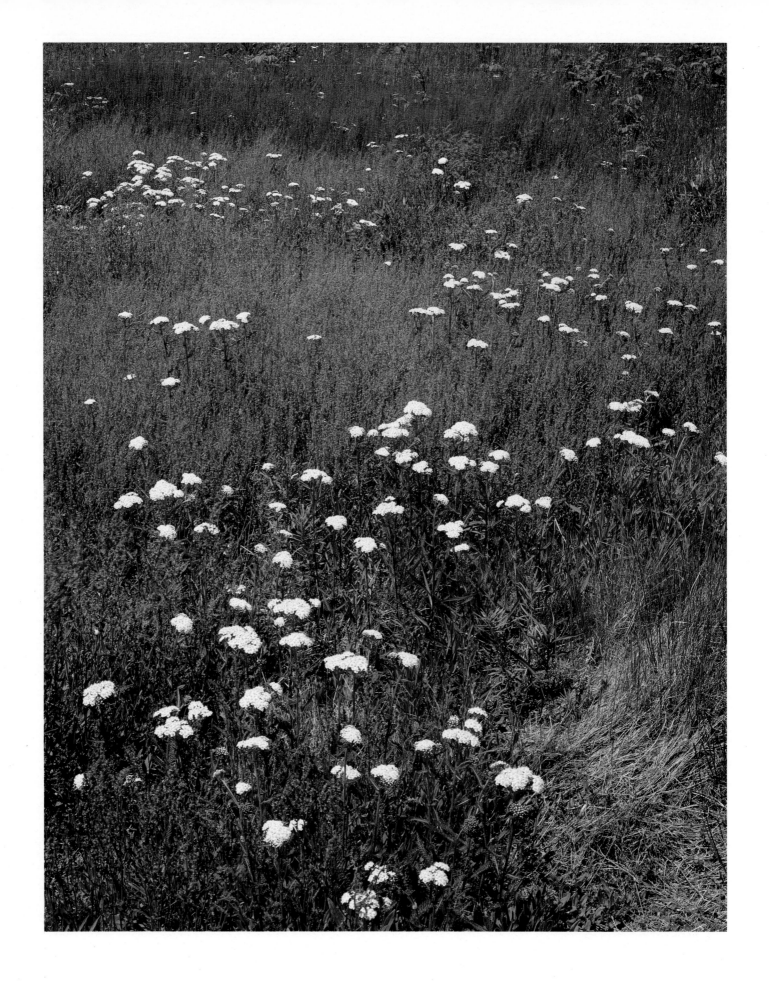

68. *Sorrel and yarrow, Oak Island, Maine, 26 June 1982*

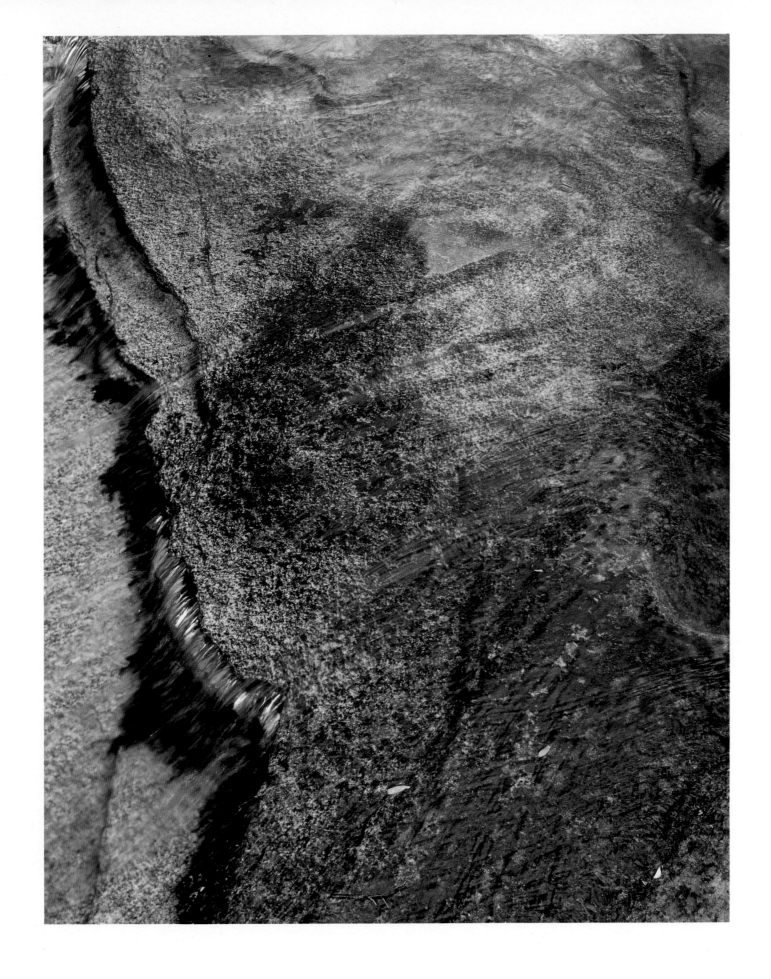

Flowing water, Davidson Creek, Pisgah National Forest, North Carolina, 18 May 1968

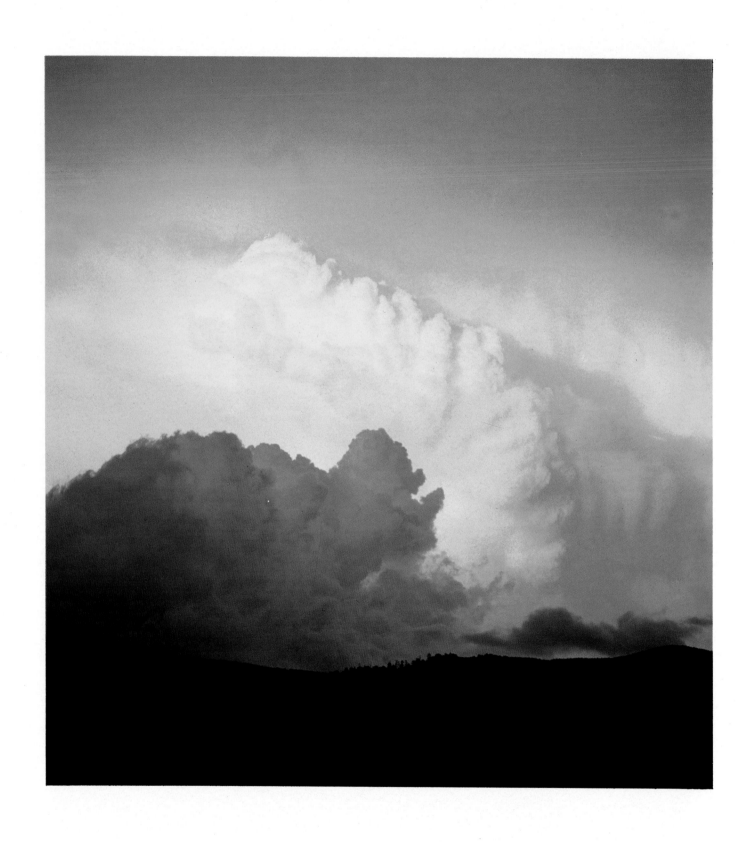

70.
Evening clouds, Tesuque, New Mexico, 3 June 1977

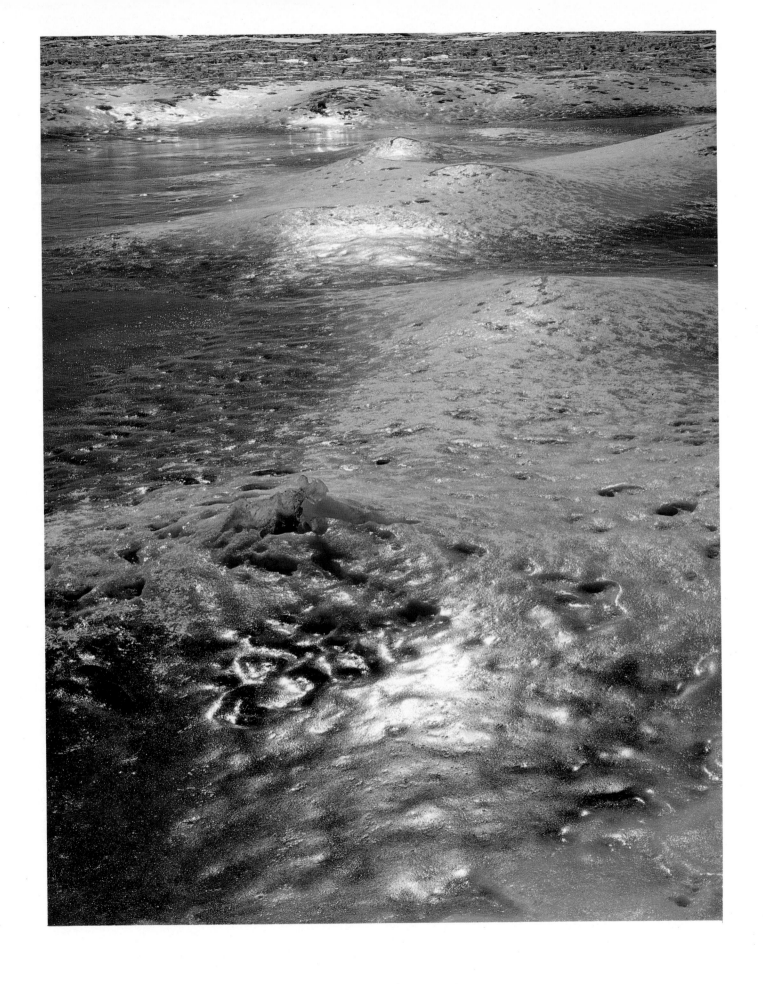

Ice heaves, New Harbor, McMurdo Sound, Antarctica, 15 December 1975

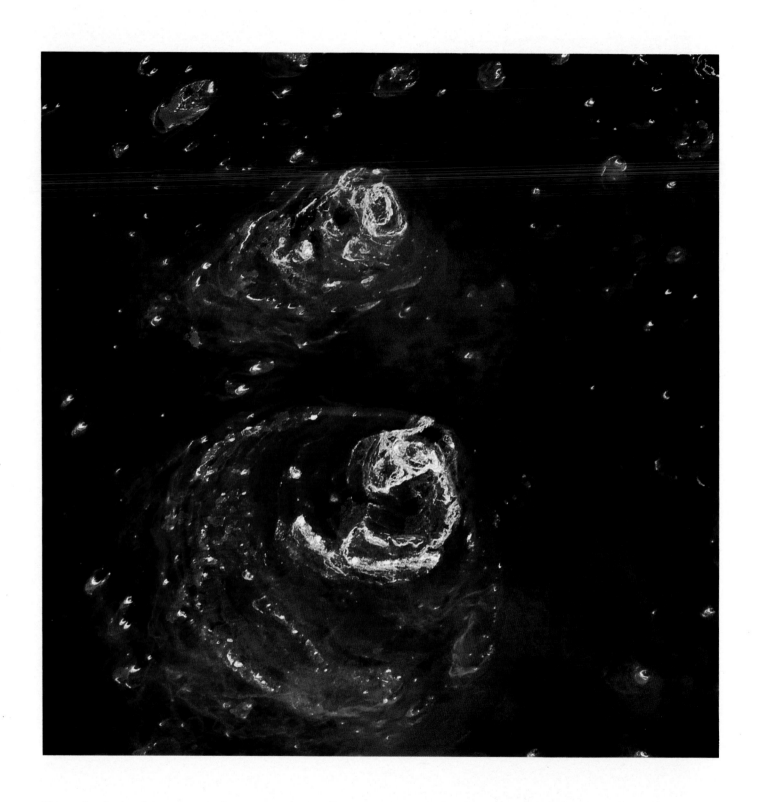

Fractal relationships govern the arrangement of cracks in a dried mud bed, the blotching of green lichen on a tree trunk, the clustering of galaxies, and the scattering of rocks on a talus slope.

Crust on Lake Natron from the air, Tanzania, Africa, 1970

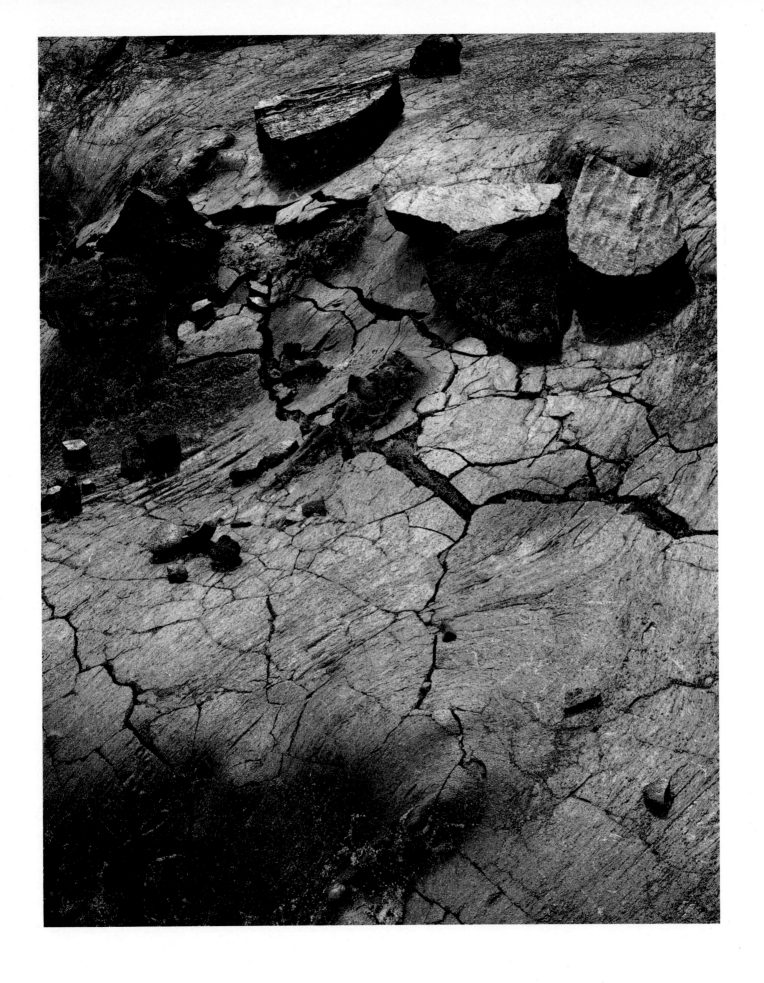

Pillow lava, Maui, Hawaii, 26 February 1979

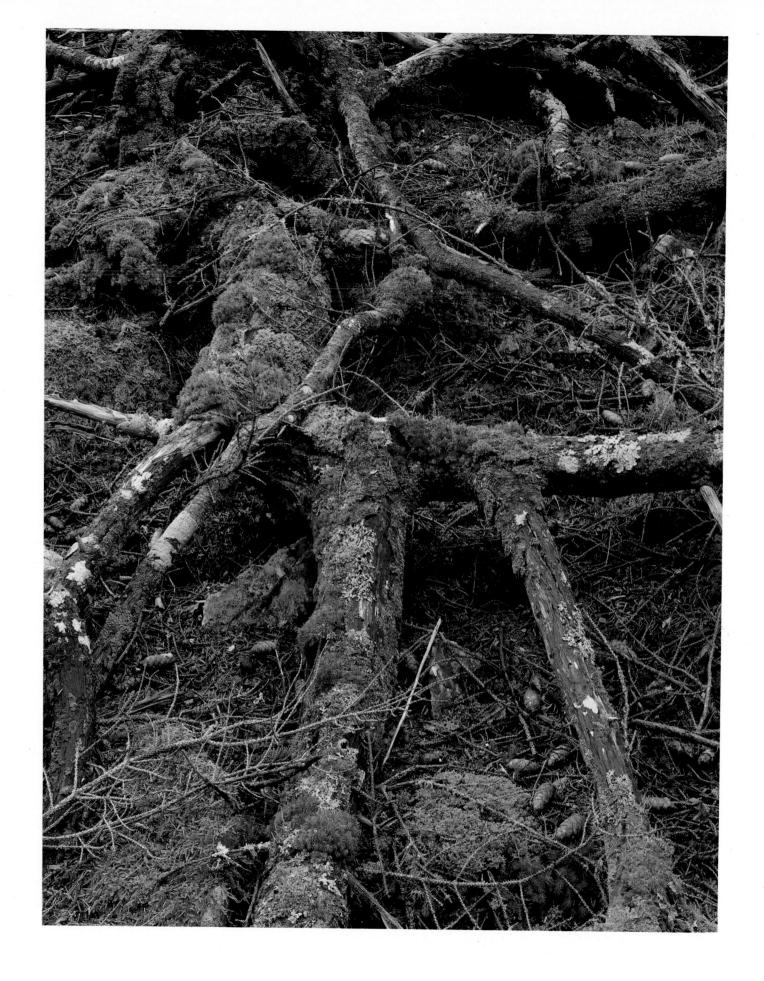

Moss-covered roots on forest floor, Great Spruce Head Island, Maine, 2 August 1982

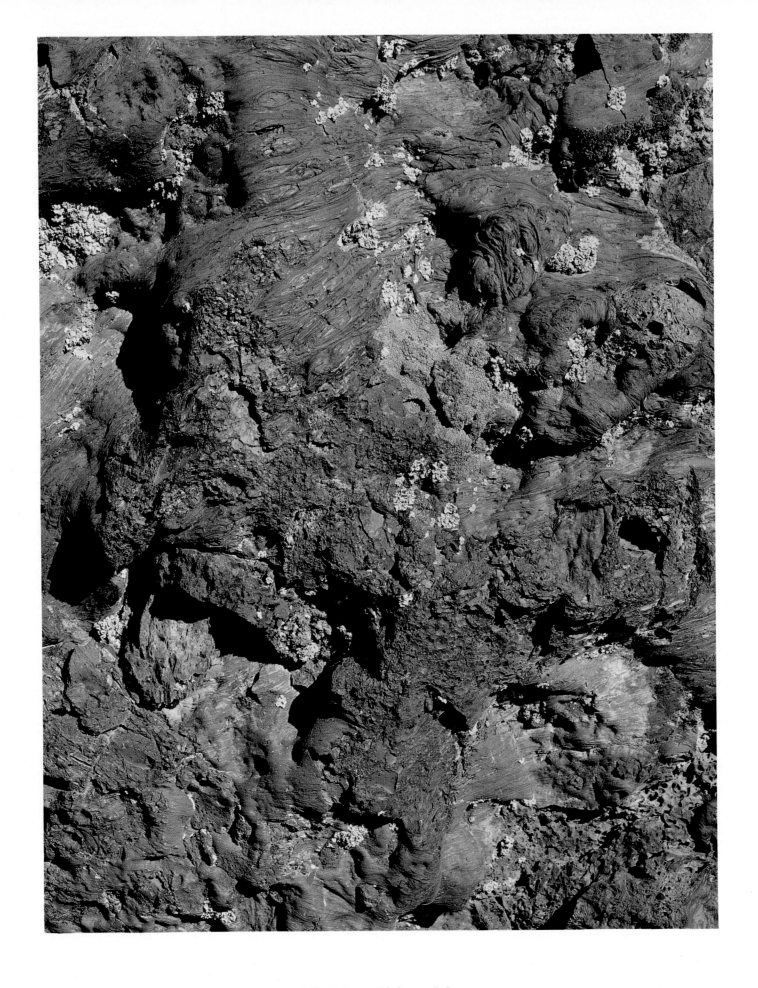

Red and black lava with lichens, Craters of the Moon, Idaho, 2 July 1975

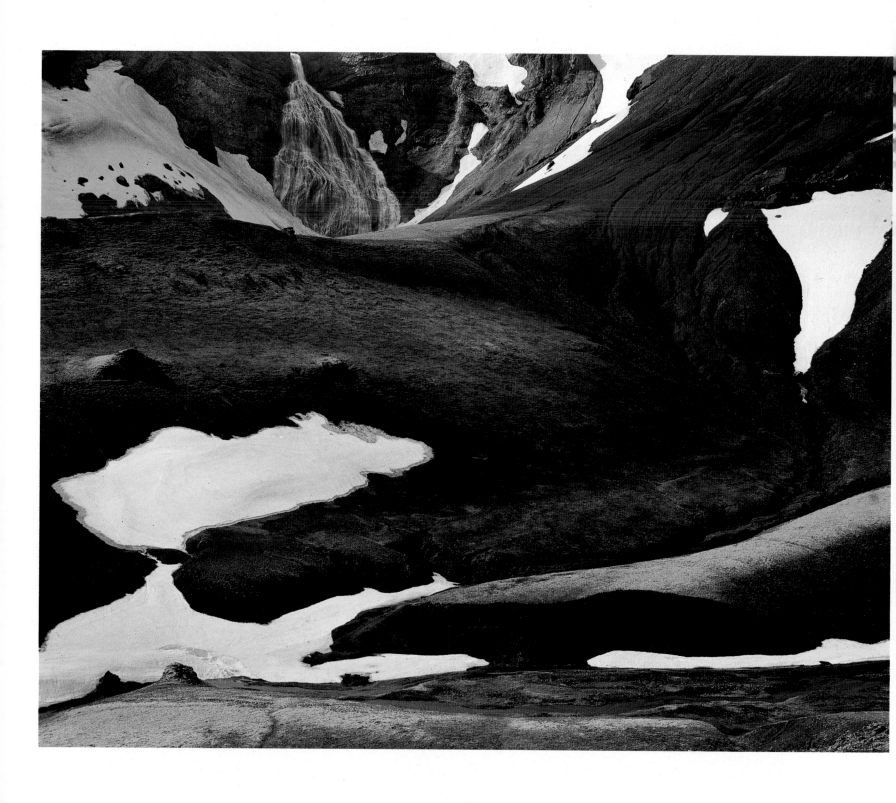

The essence of the earth's beauty lies in disorder, a peculiarly patterned disorder, from the fierce tumult of rushing water to the tangled filigrees of unbridled vegetation.

76.

Waterfall near Landmannahellir, Iceland, 28 June 1972

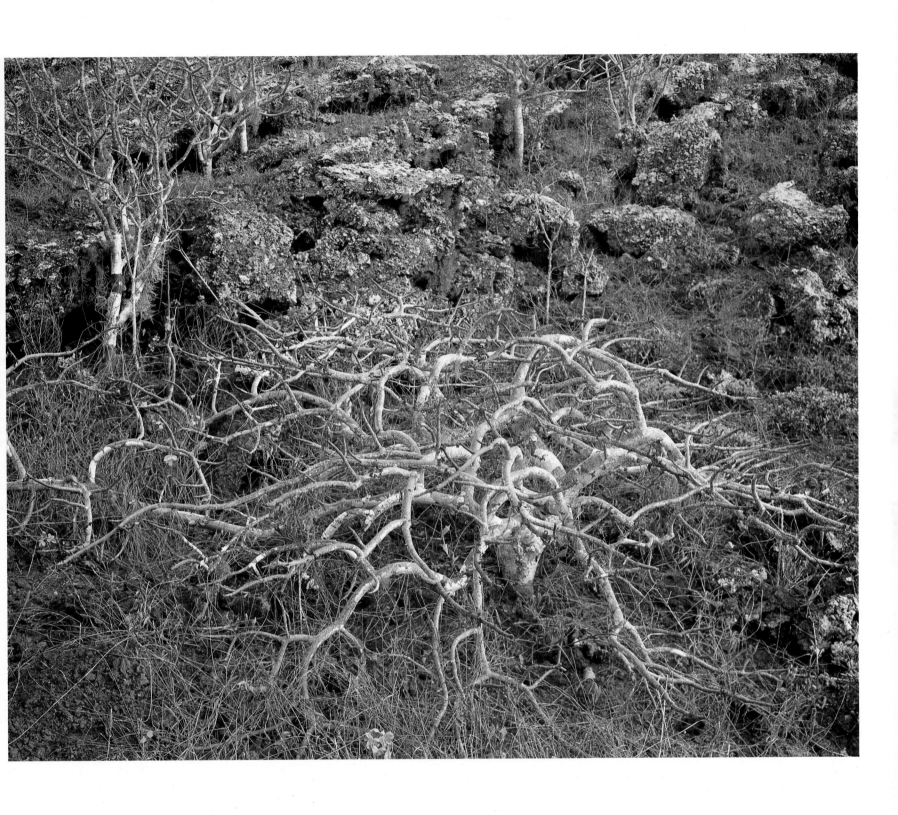

Palo Santo and lichen, Jervis Island, Galápagos Islands, 1 April 1966

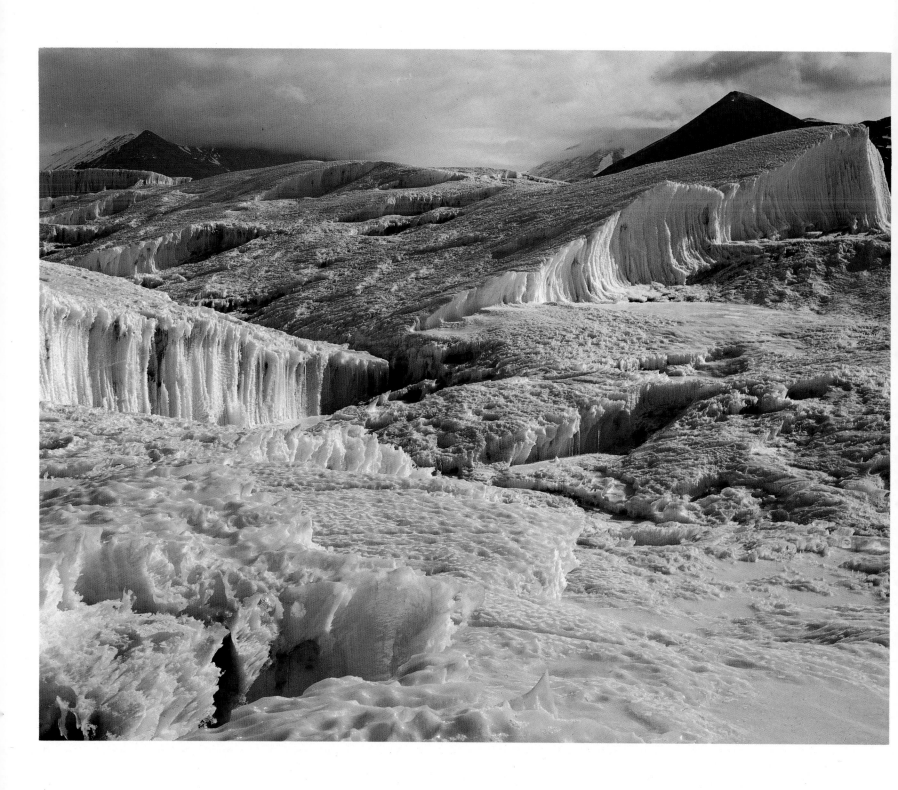

78. *Koettlitz Glacier, McMurdo Sound, Antarctica, 17 December 1975*

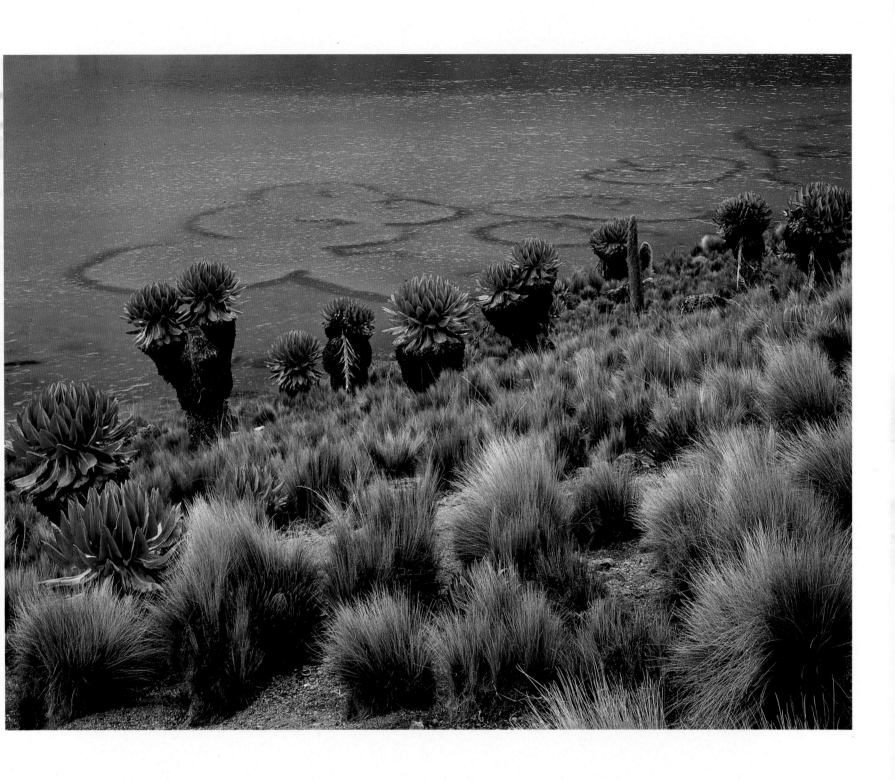

Even the most random-seeming of the earth's images . . . distribute themselves according to laws that subtly organize the relation of large things to small.

Teleki Tarn, Mt. Kenya, Africa, 14 February 1970

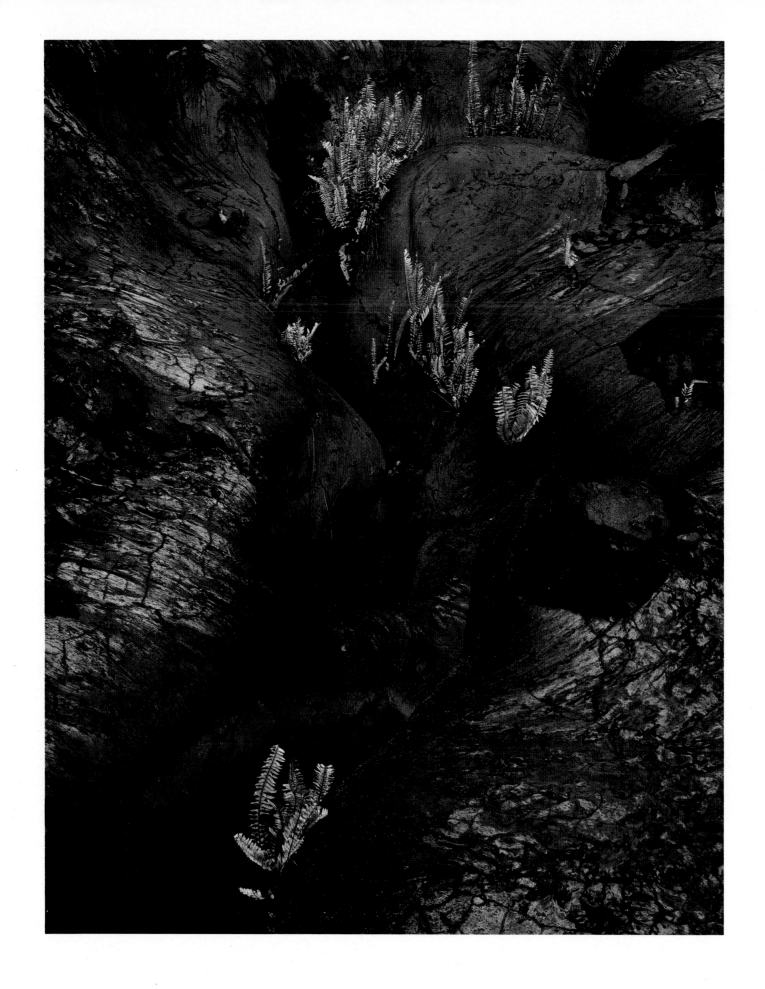

80. *Ferns in lava rift, Pauahi Crater, Hawaii, 27 February 1979*

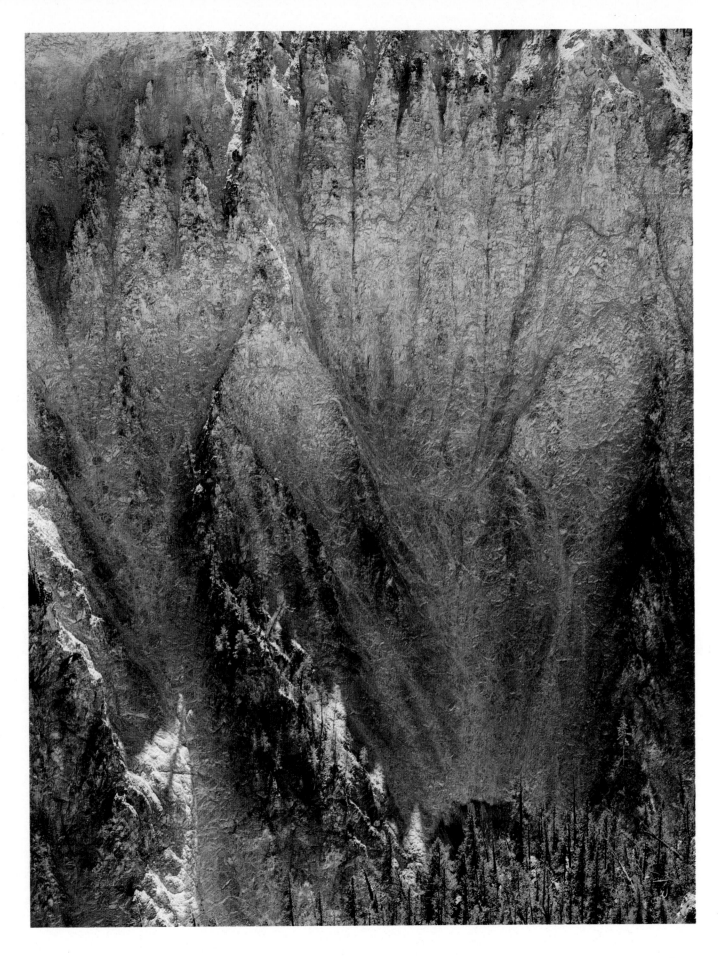

Canyon wall, Yellowstone River Canyon, Yellowstone National Park, Wyoming,
29 August 1979

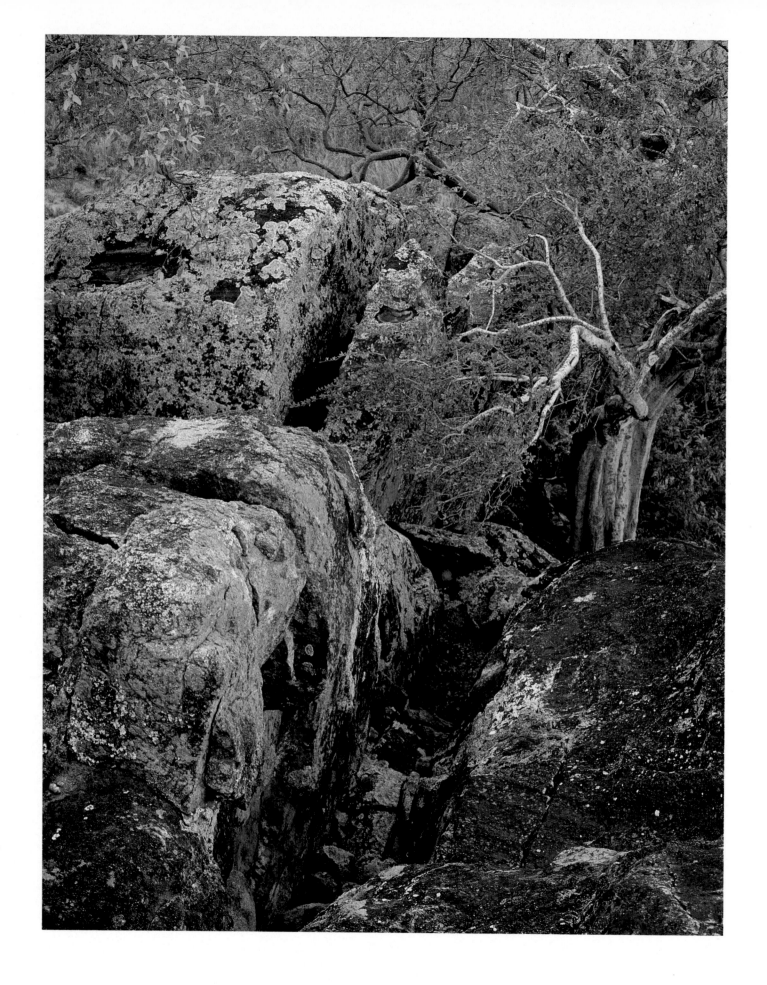

82. *Kopjes rock and trees, Kidepo National Park, Uganda, Africa, 13 August 1970*

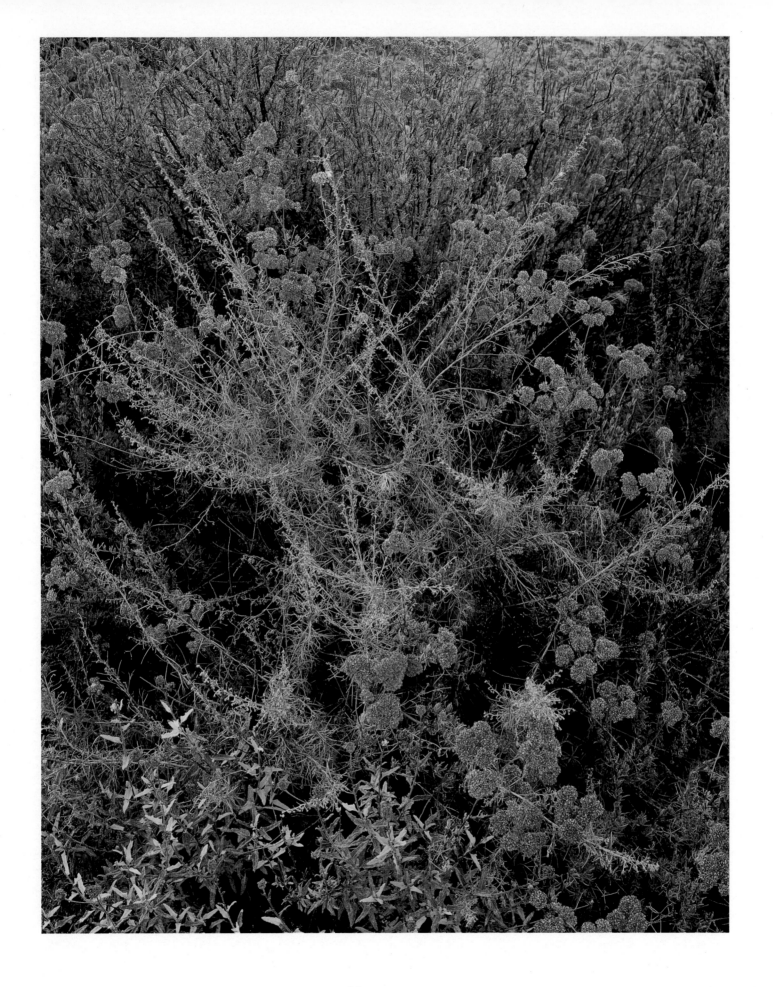

Vegetation detail, Calenturas, Mexico, 25 July 1966

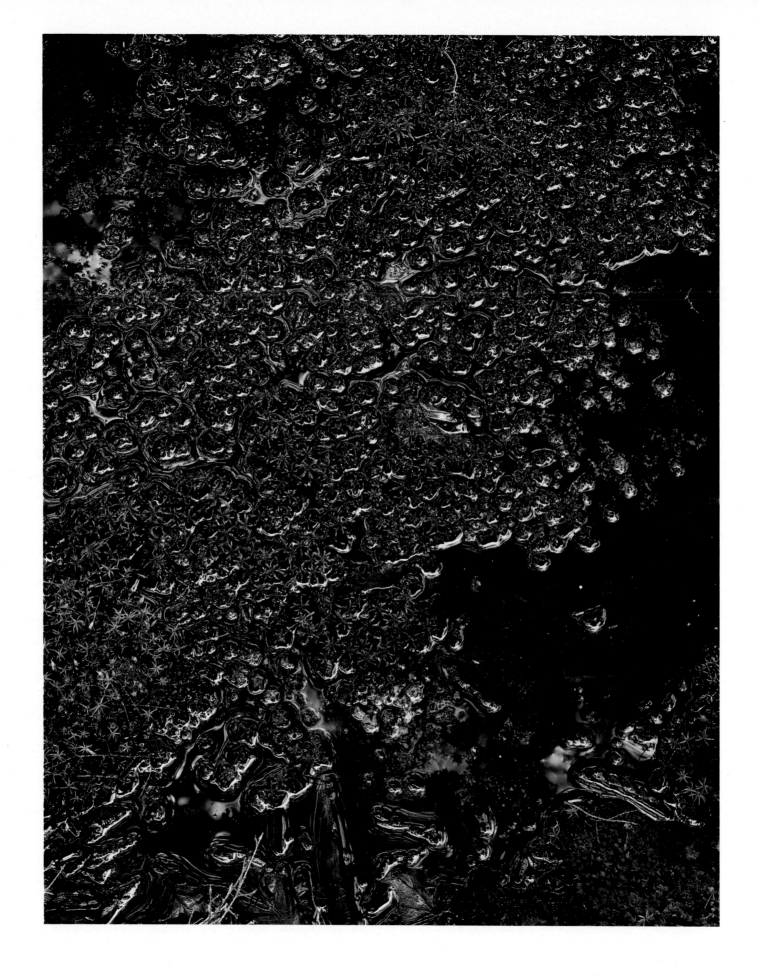

84. *Moss in bog pool, Seney, Michigan, 18 June 1973*

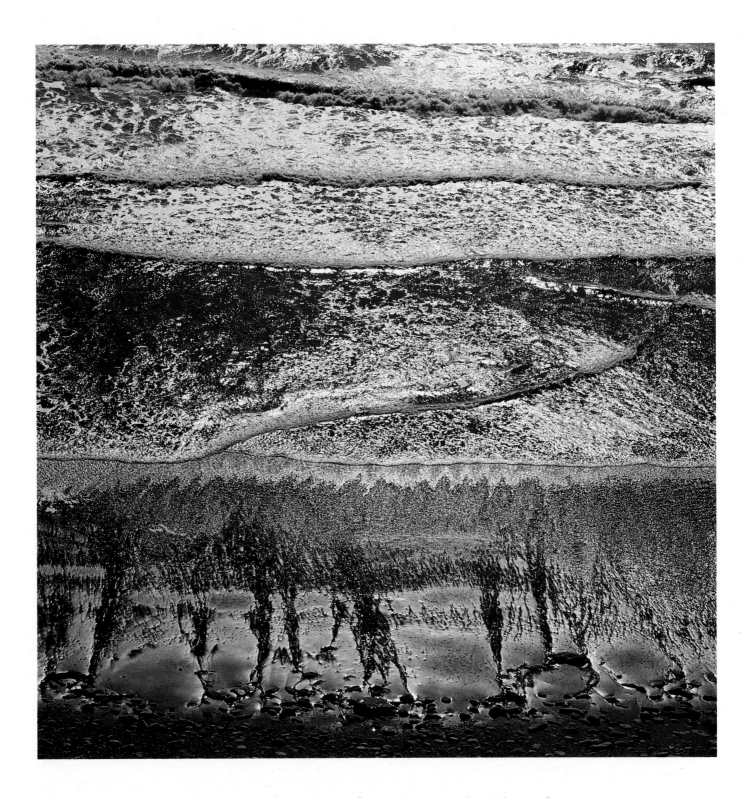

Scales change, patterns change again. By seeing the forms that repeat themselves on large and small scales, scientists have deepened their understanding of the patterns that fail to repeat themselves . . .

Waves on beach, California, August 1975

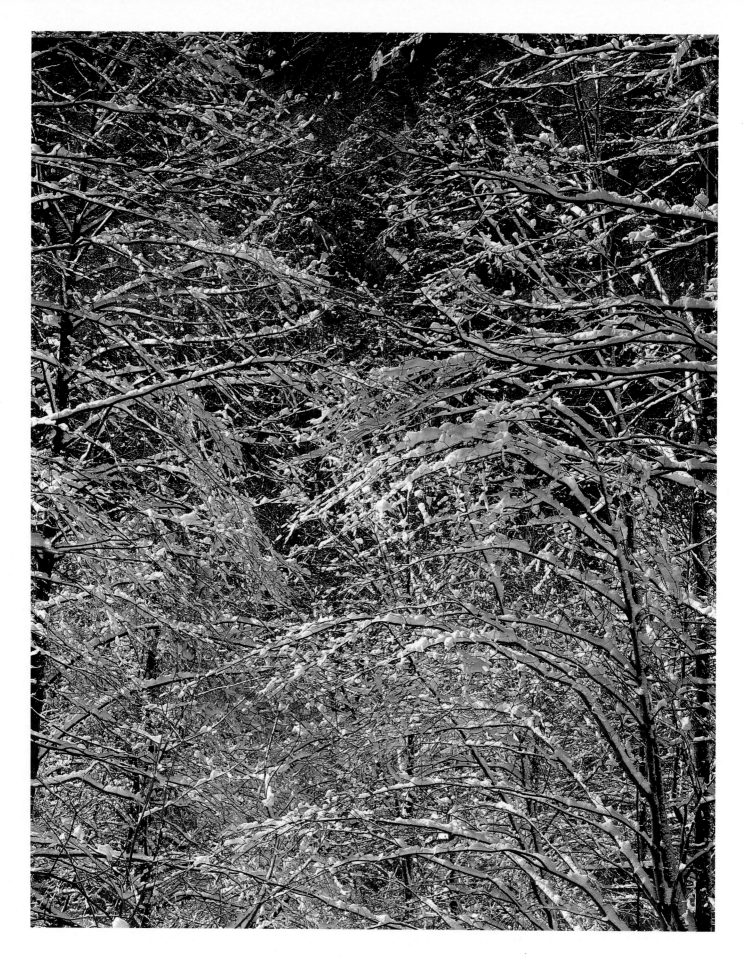

Snow-covered small trees, Great Smoky Mountains National Park, Tennessee,
12 March 1969

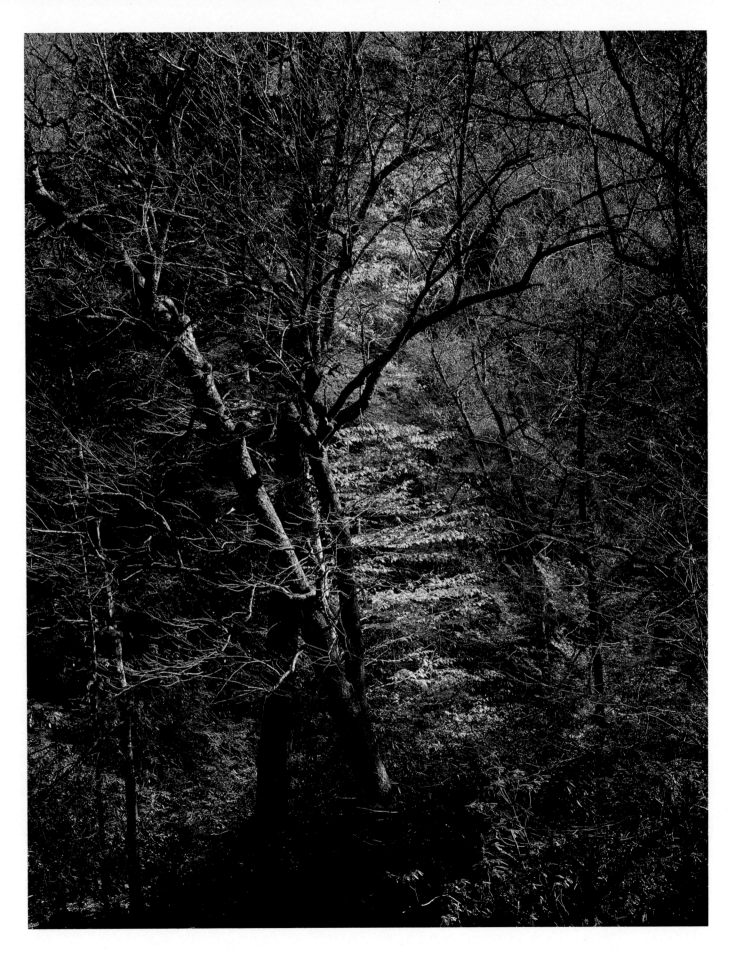

Beech and bare trees, West Prong, Little Pigeon River, Great Smoky Mountains
National Park, Tennessee, 13 October 1967

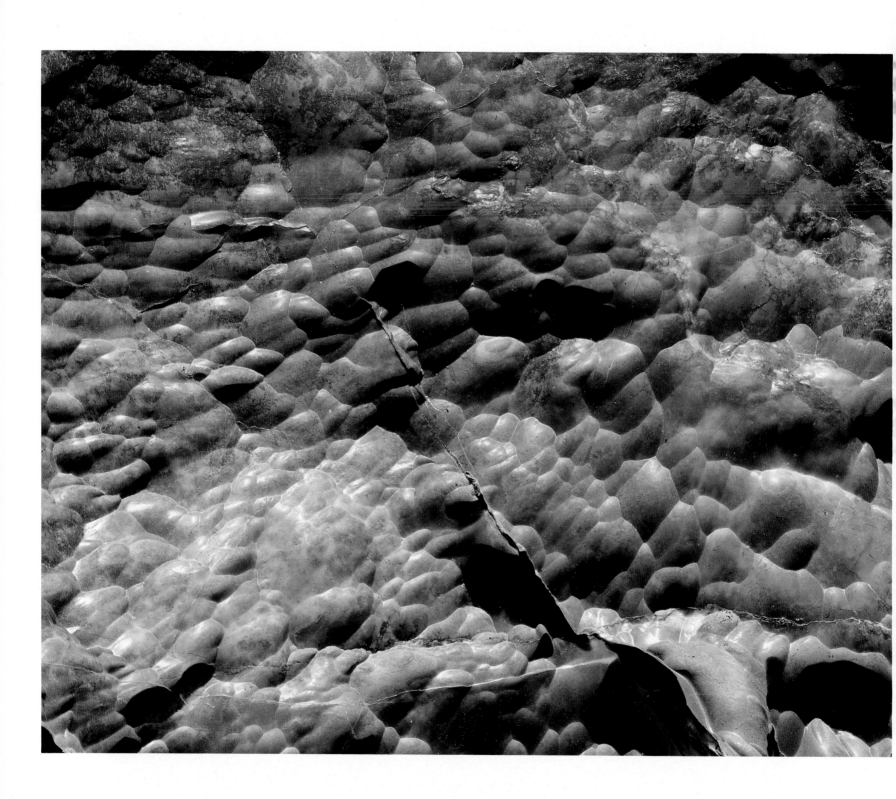

The study of chaos has provided a seemingly paradoxical insight: that rich kinds of order, as well as chaos, can arise — arise spontaneously — from the unplanned interaction of many simple things.

Fluted limestone, Mile 26, Marble Canyon, Arizona, 13 September 1967

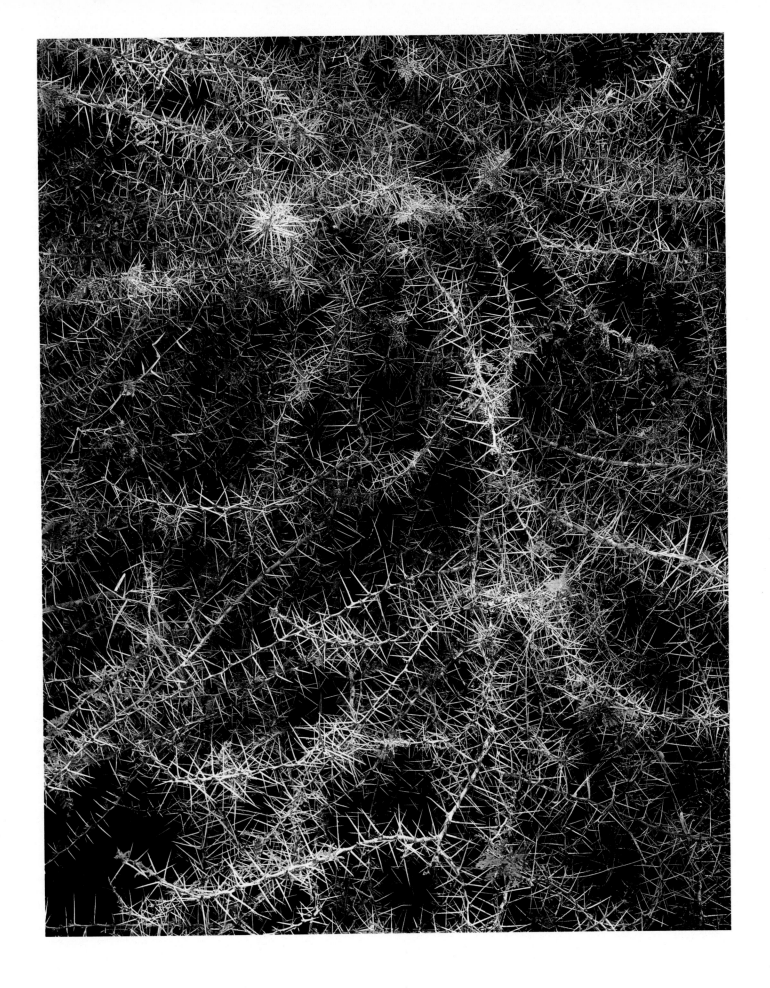

Detail of a thorn acacia tree, Amboseli, Kenya, Africa, 16 September 1970

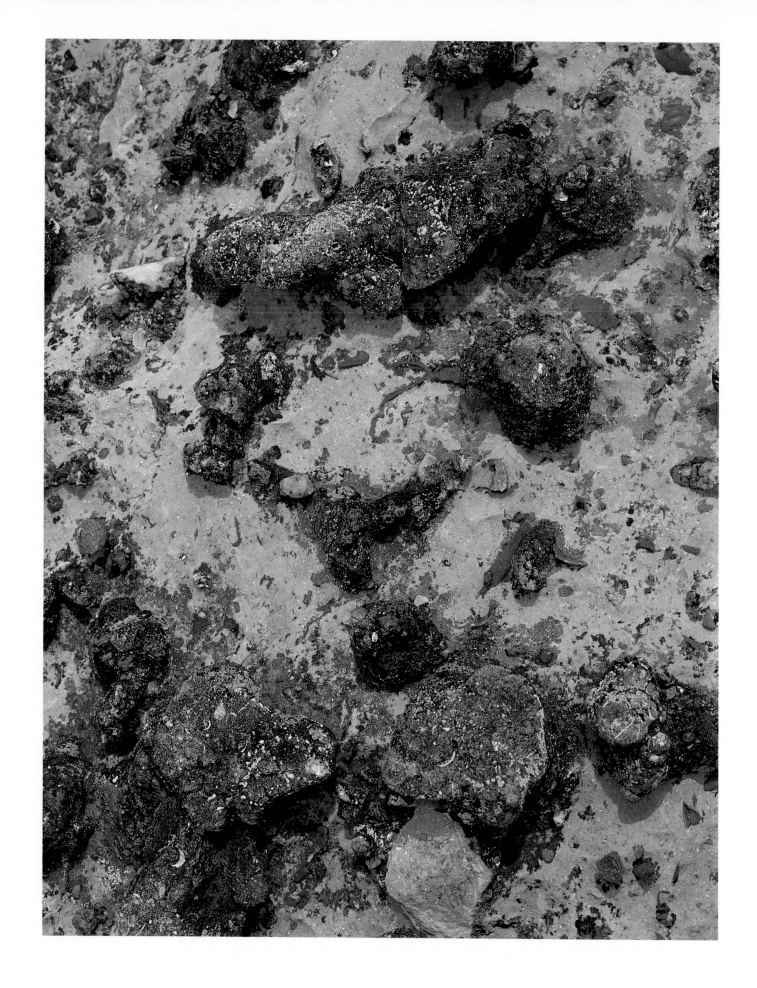

Jasperized fossils in sandstone, Boysag Point, Arizona, 17 August 1969

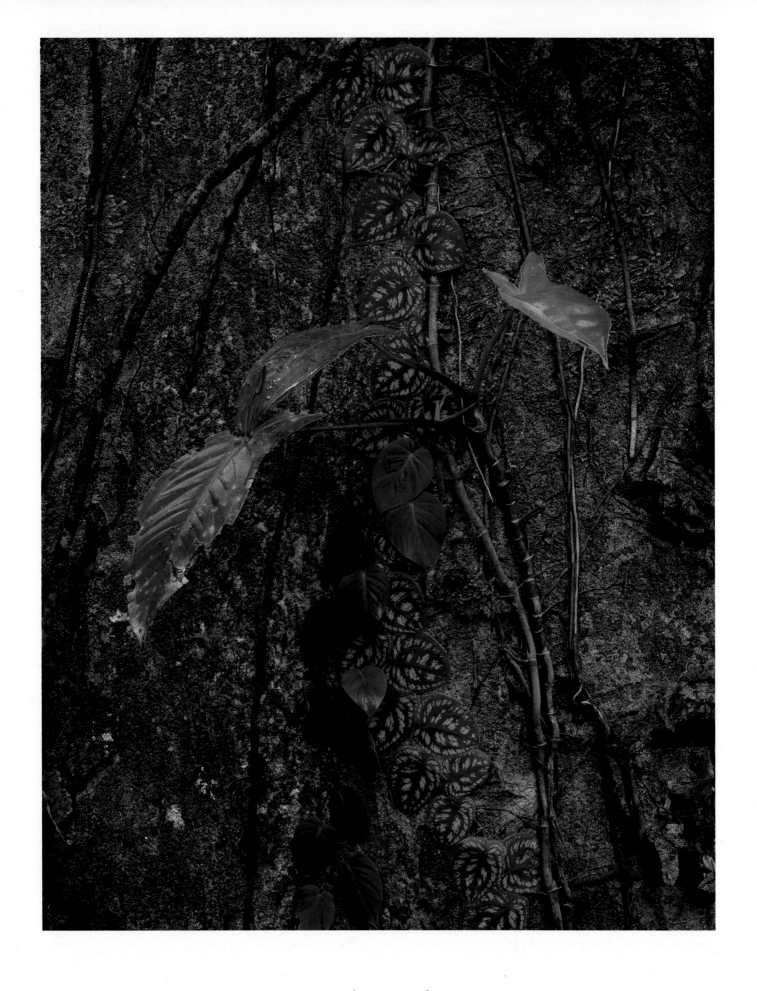

Vine on tree trunk, Tortuguero Park, Costa Rica, 8 March 1984

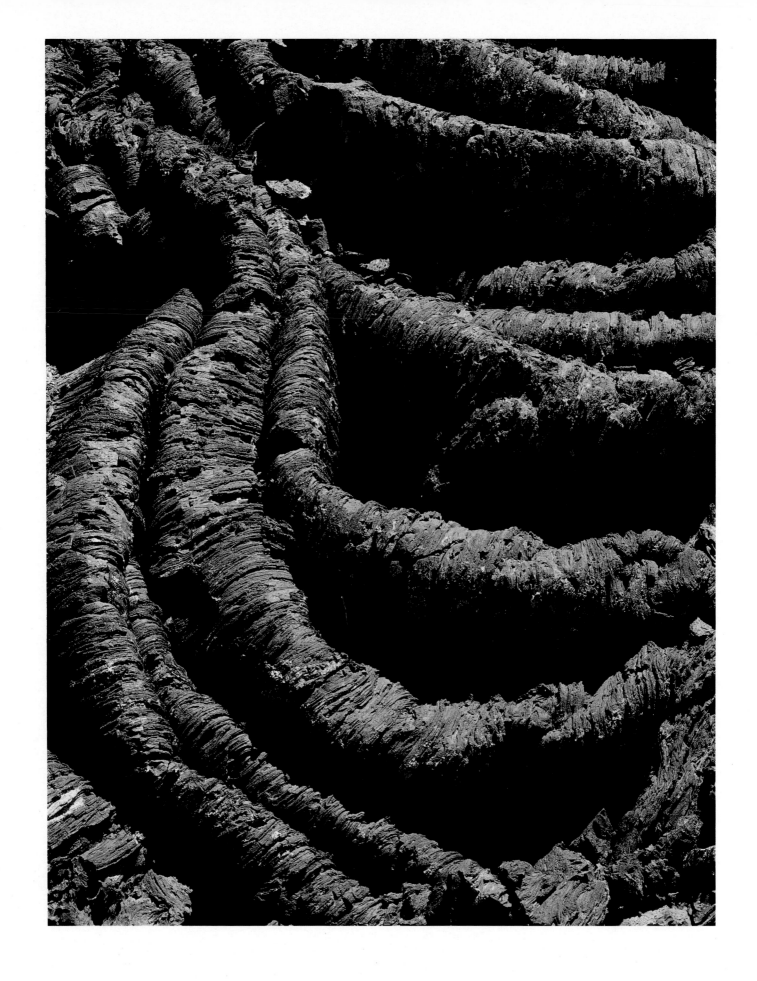

Pahoehoe rope lava, Craters of the Moon, Idaho, 2 July 1975

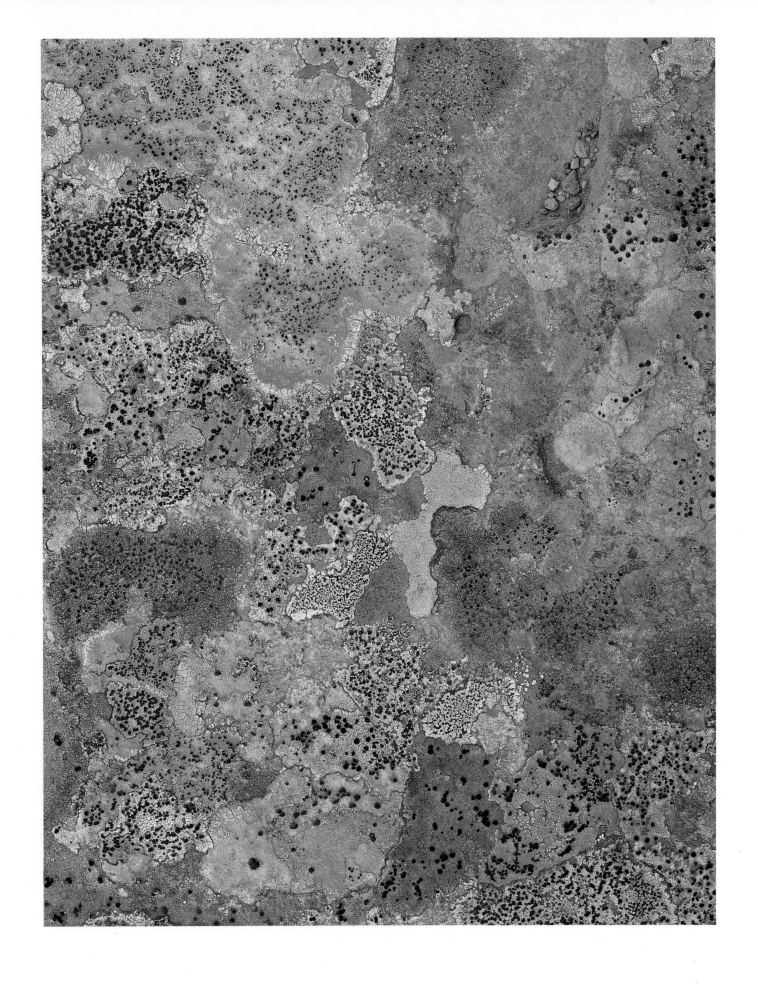

Lichens on rock, road to Laki, Iceland, 3 July 1972

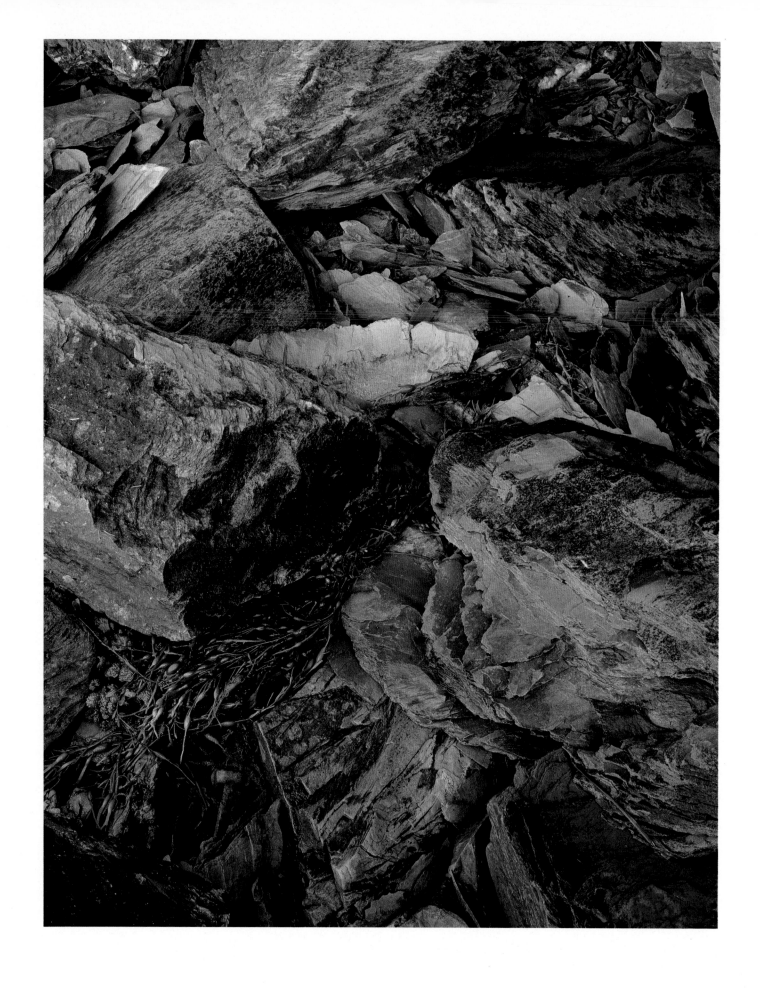

Brown shale rock, Bradbury Island, Maine, 25 August 1973

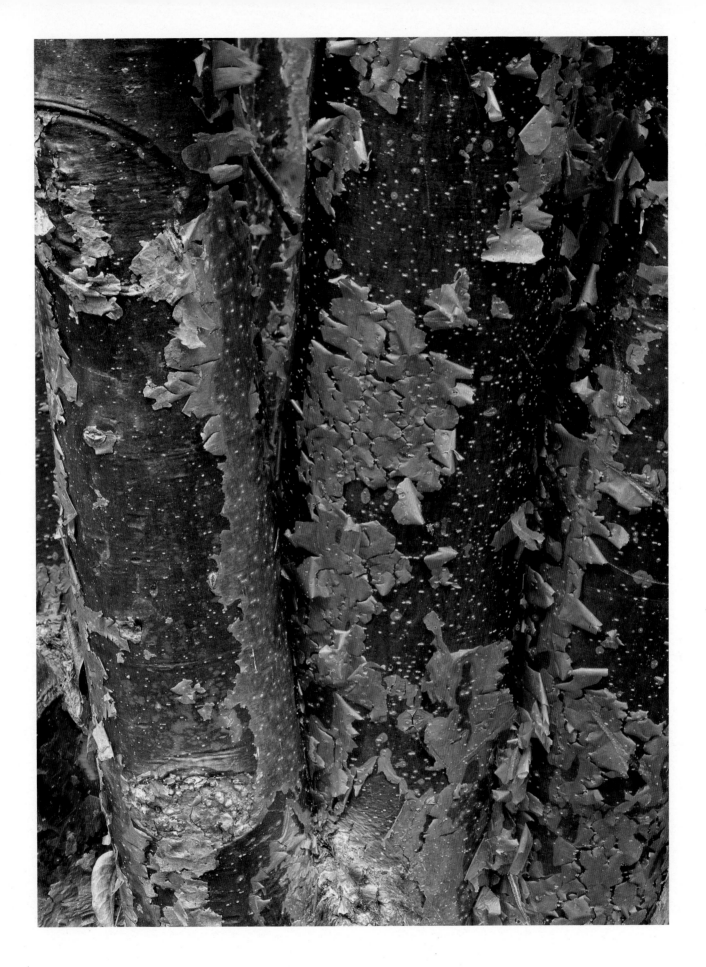

Gumbo Limbo bark, Bear Lake Trail, Everglades National Park, Florida,
24 February 1974

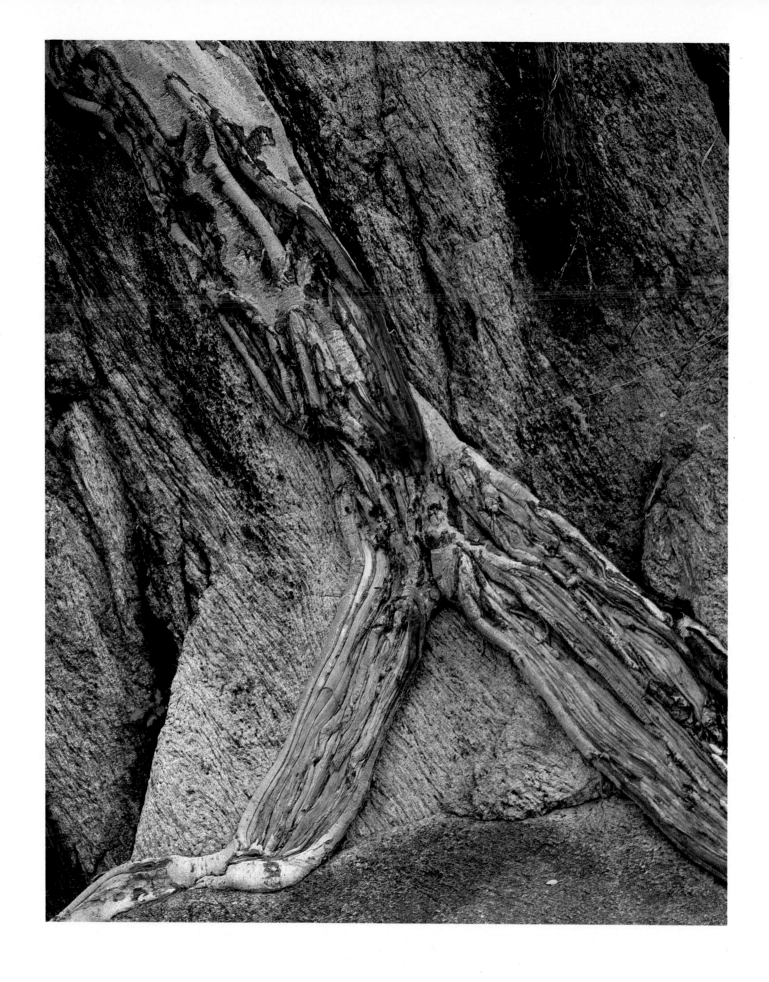

96. *Tree root on rock, Murchison Falls Park, Uganda, Africa, 10 August 1970*

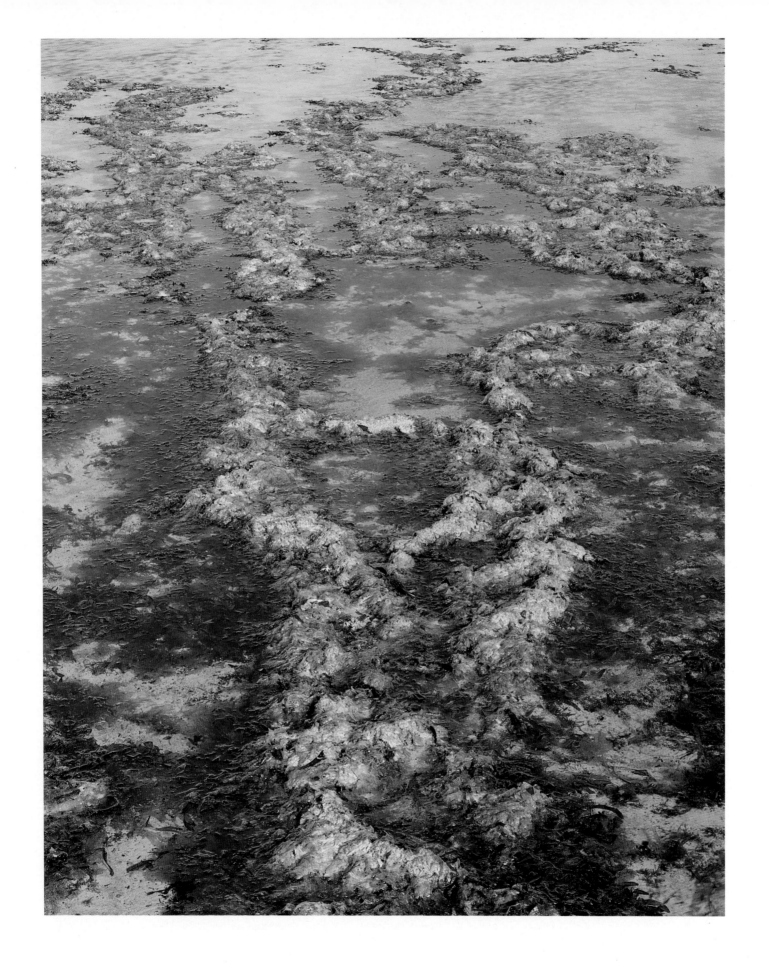

Green algae at low tide, south of Mombasa, Kenya, Africa, 22 October 1970

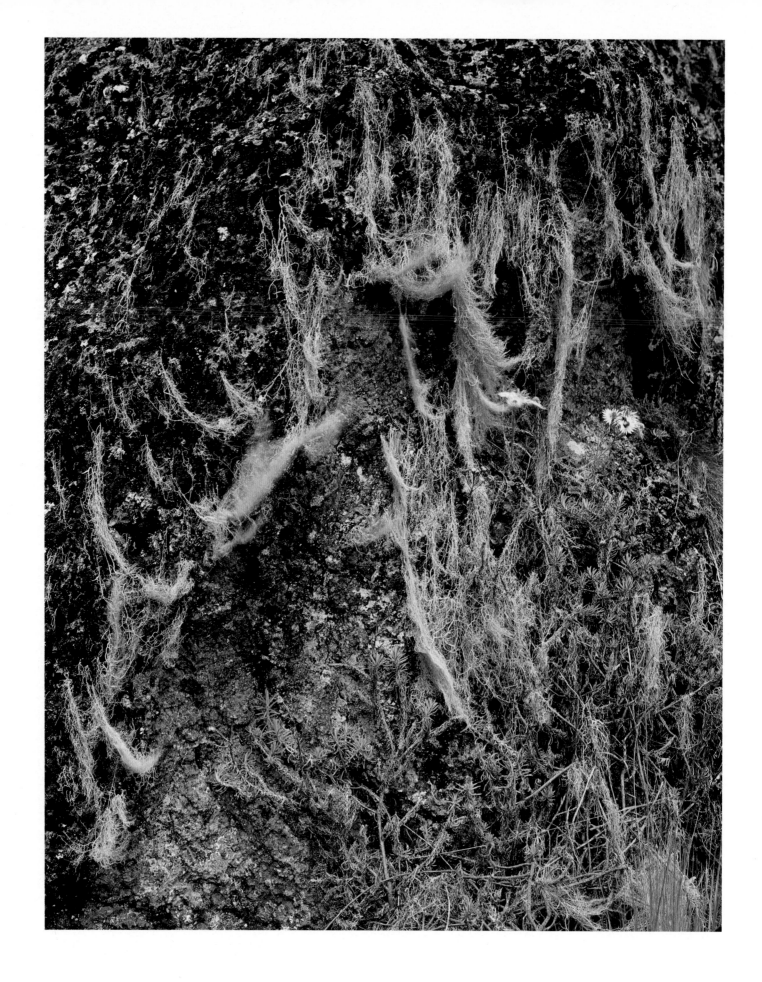

98. *Beard moss lichens, Teleki Ridge, Mt. Kenya, Africa, 12 February 1970*

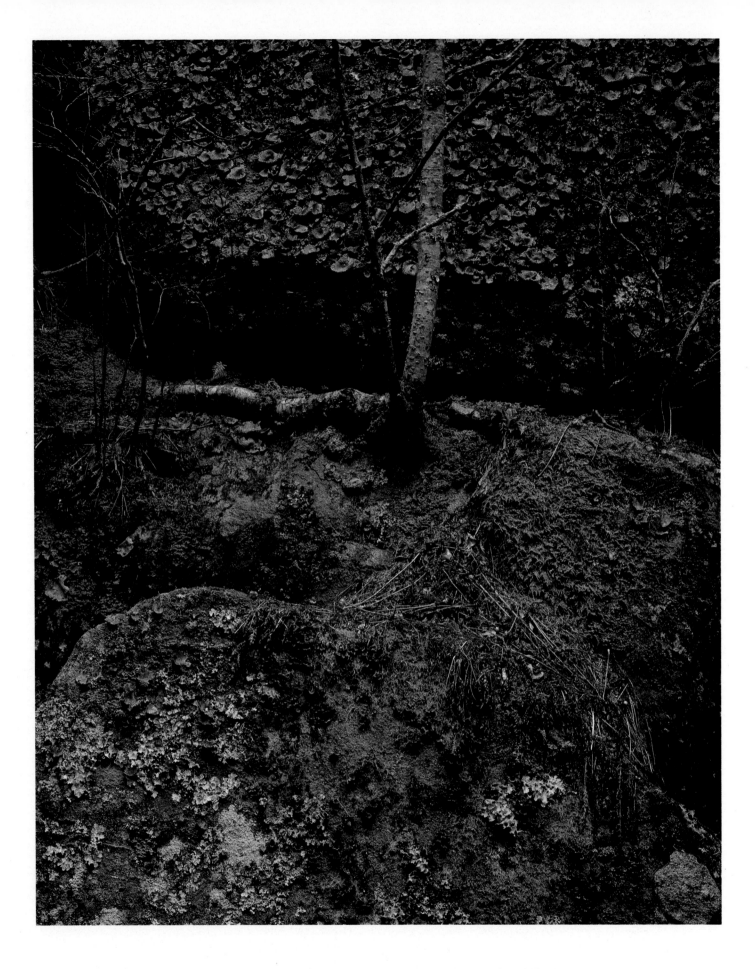

Lichens and moss on rock, Clingman's Dome, Great Smoky Mountains National Park,
North Carolina, 11 May 1968

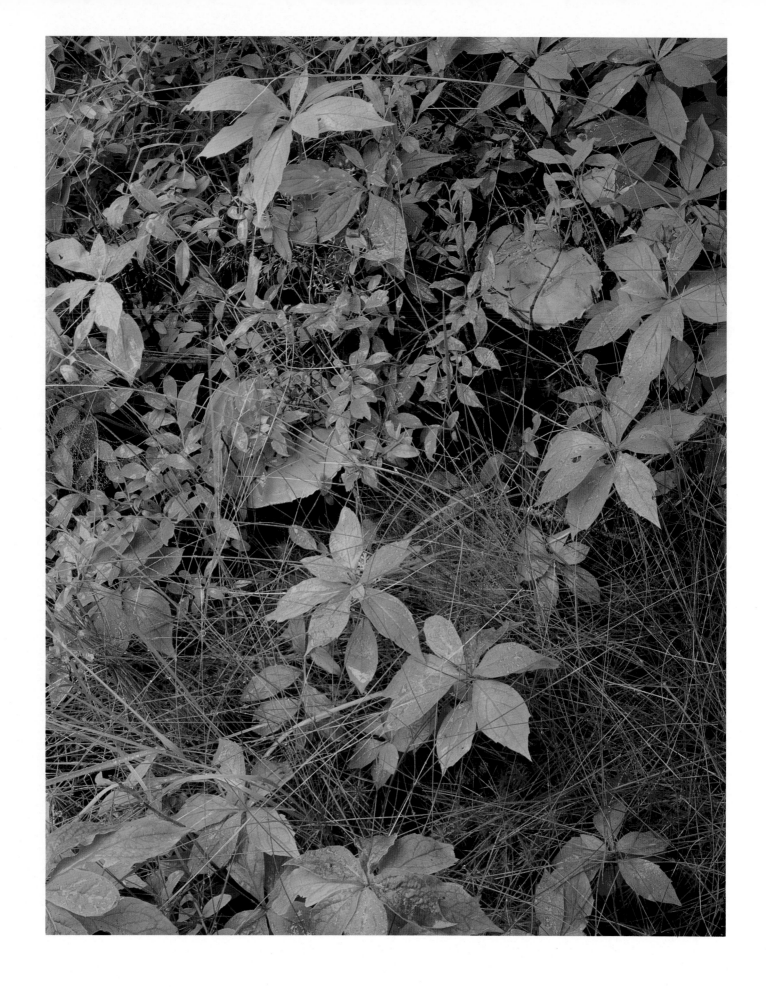

100. *Cantharella in grass, Great Spruce Head Island, Maine, 4 August 1973*

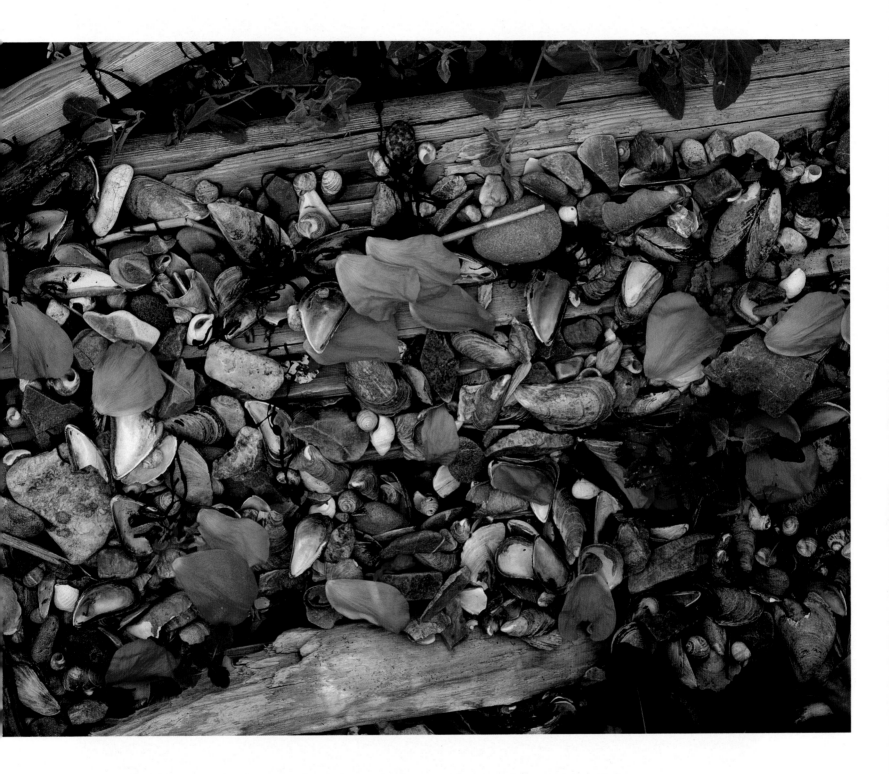

. . . *waiting within the disorder of grasses strewn in a meadow or talus across a rock face,*
uncanny kinds of structure, more subtle and intricate than any human gardener or sculptor
could arrange.

Rose petals and mussel shells, Driftwood Beach, Great Spruce Head Island, Maine,
1 July 1971

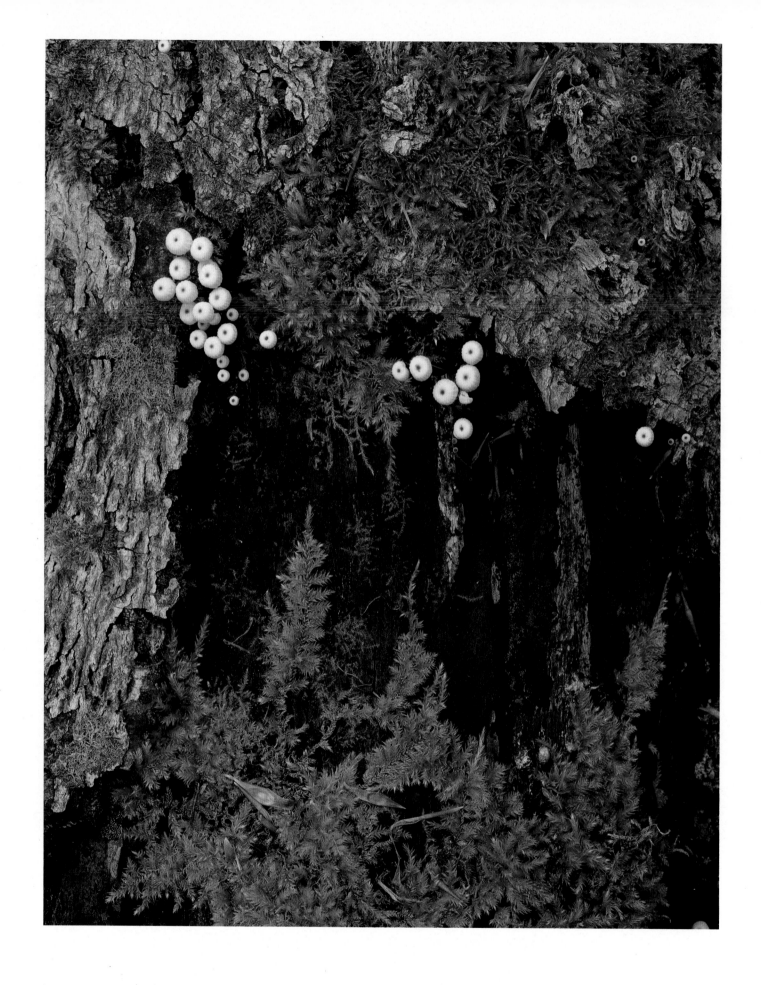

Mushrooms and moss on log, Adams Trail, Seney, Michigan, *19 June 1973*

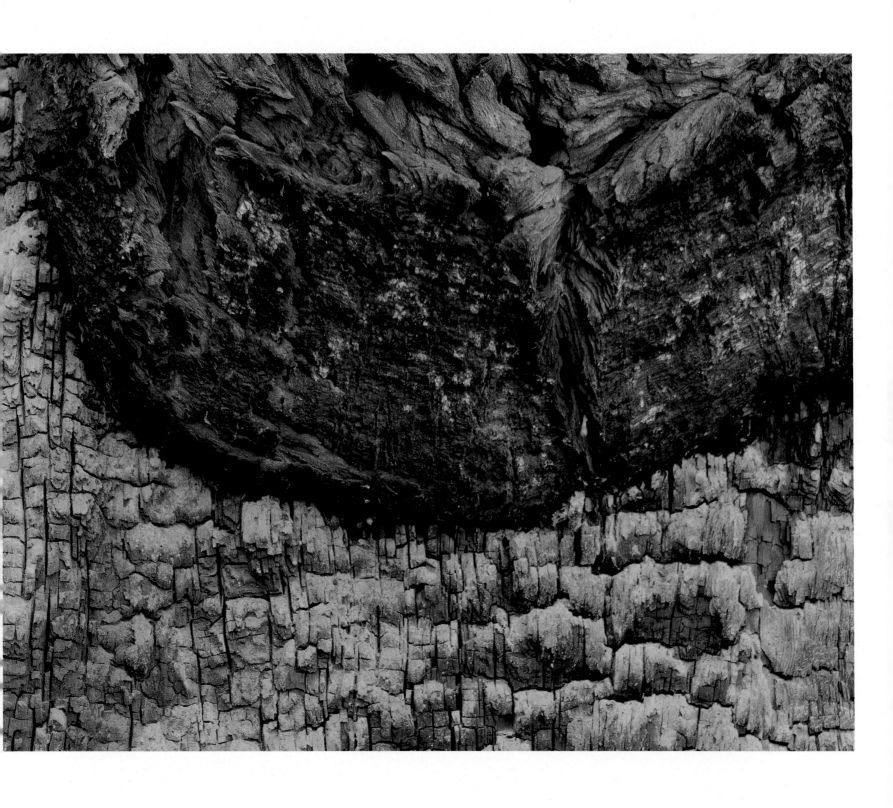

Charred redwood tree, L. B. J. Grove, Redwood National Park, California,
7 August 1975

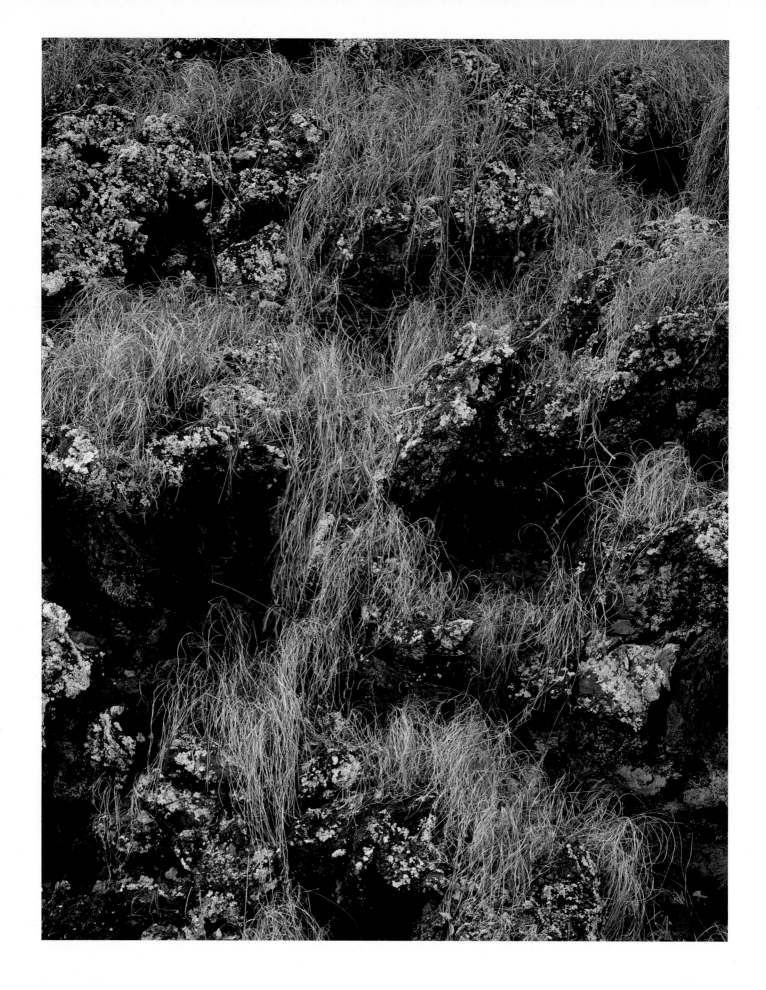

104. *Grass on lava flow, Tsavo West, Kenya, Africa, 10 October 1970*

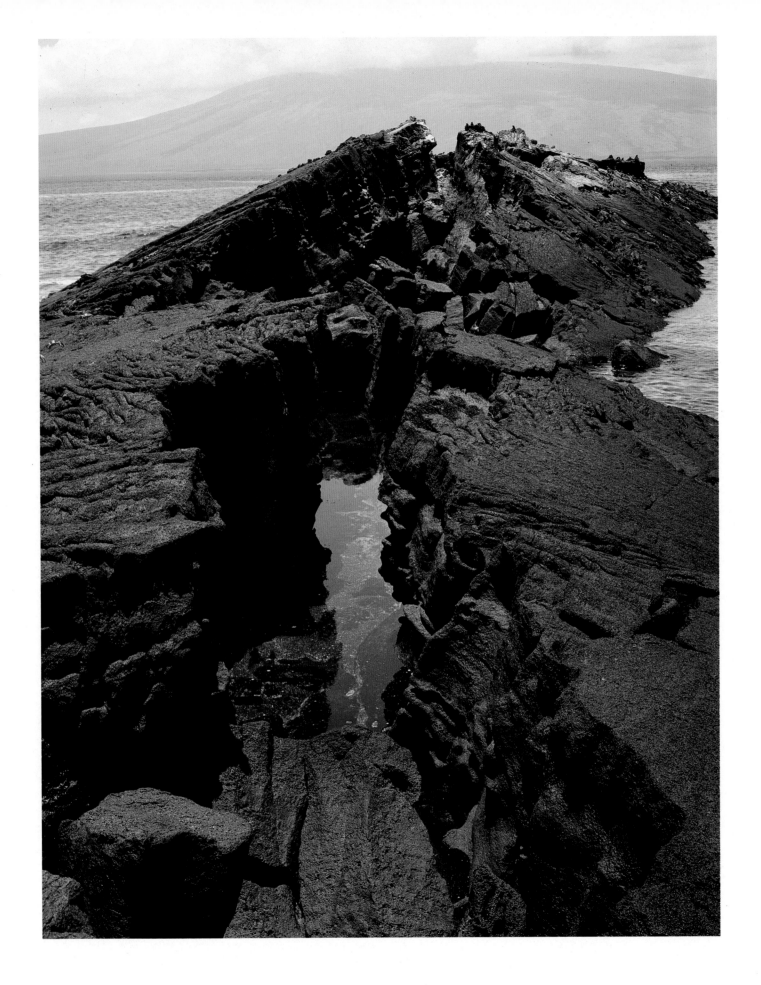

Lava crack, Espinosa Point, Galápagos Islands, 7 April 1966

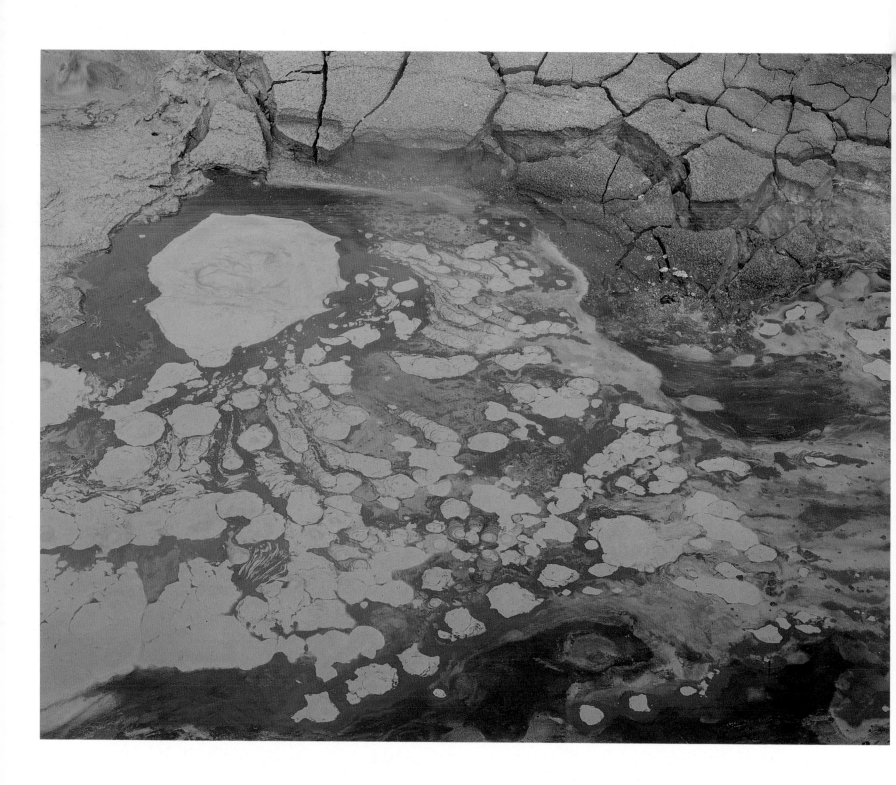

106. *Mud pot, Mývatn, Iceland, 23 July 1972*

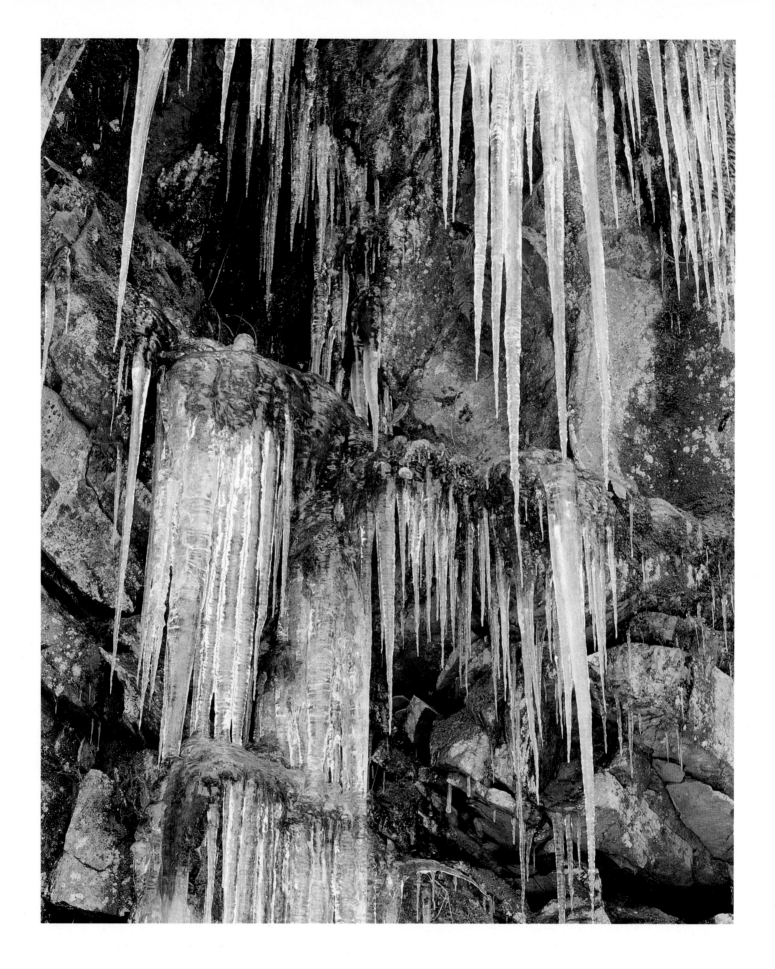

Icicles on cliff, Roaring Fork, Great Smoky Mountains National Park, Tennessee,
12 March 1969

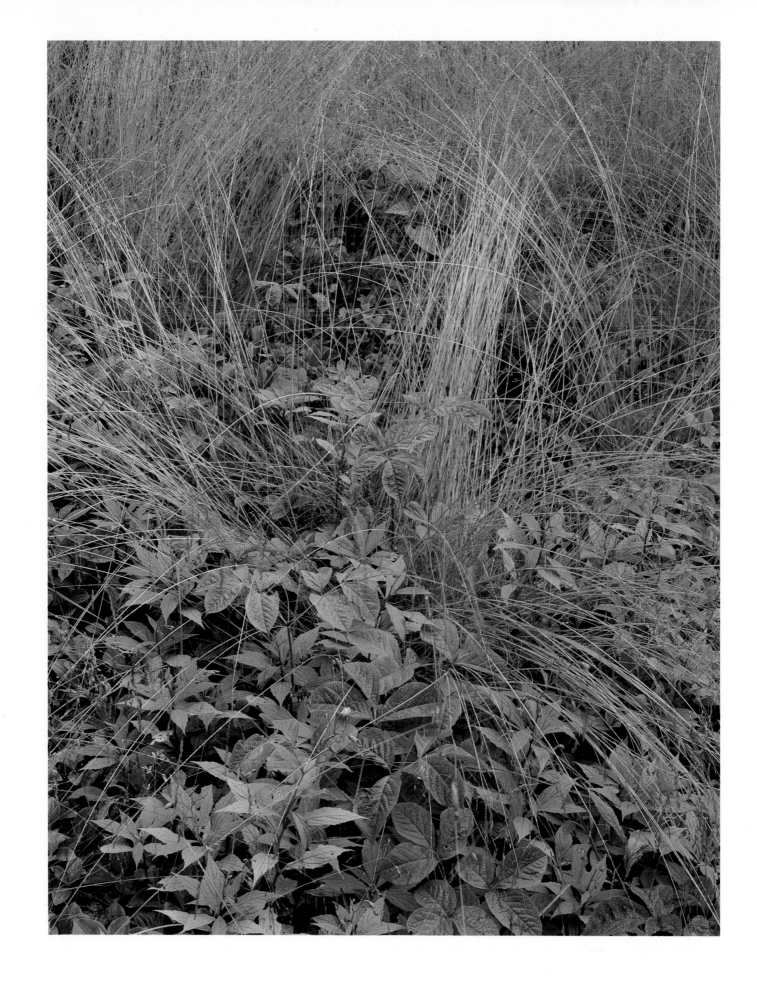

108. *Long-stemmed grasses, Great Spruce Head Island, Maine, 1 August 1973*

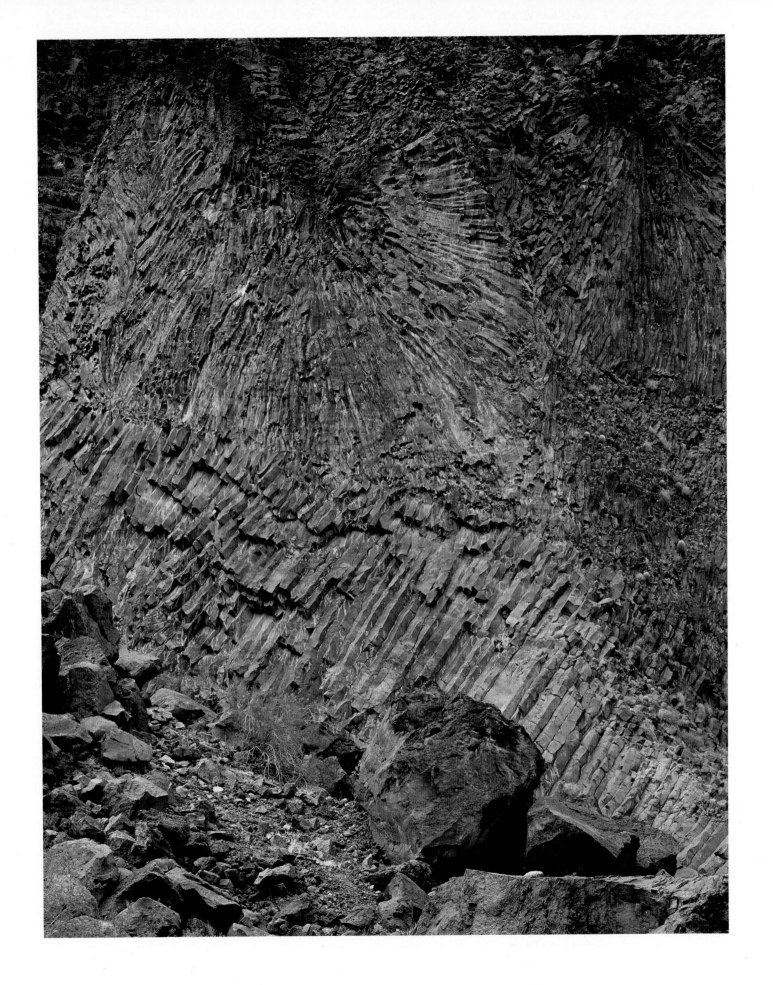

Columnar basalt cliff, Whitmore Wash, Grand Canyon, Arizona, 15 August 1969

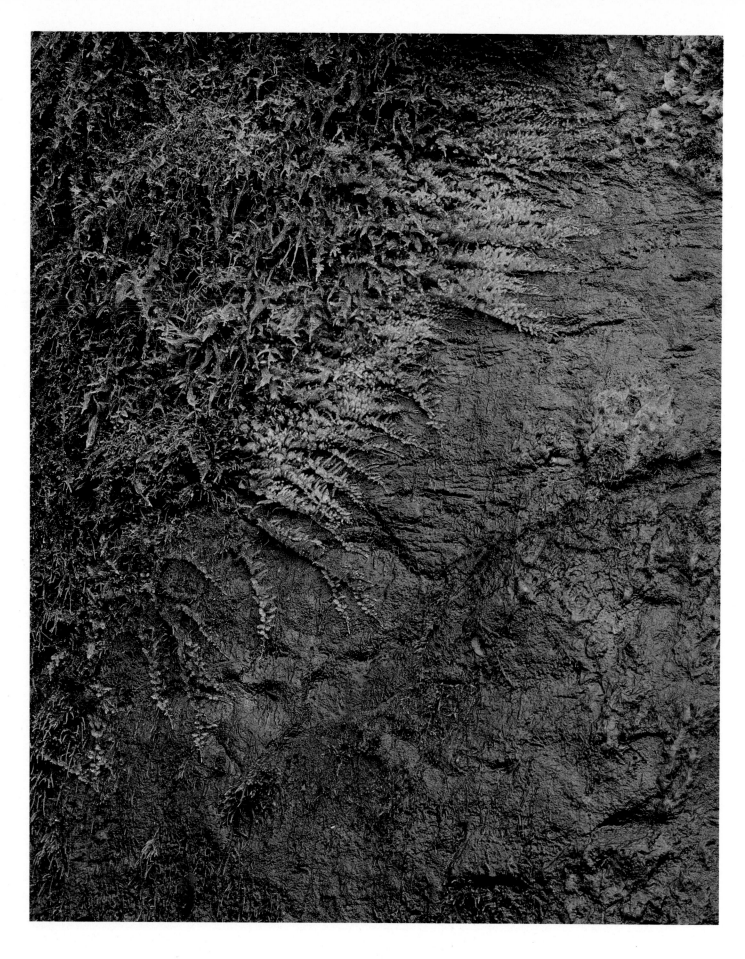

Moss on rock, Roaring Fork, Great Smoky Mountains National Park, Tennessee,
10 October 1967

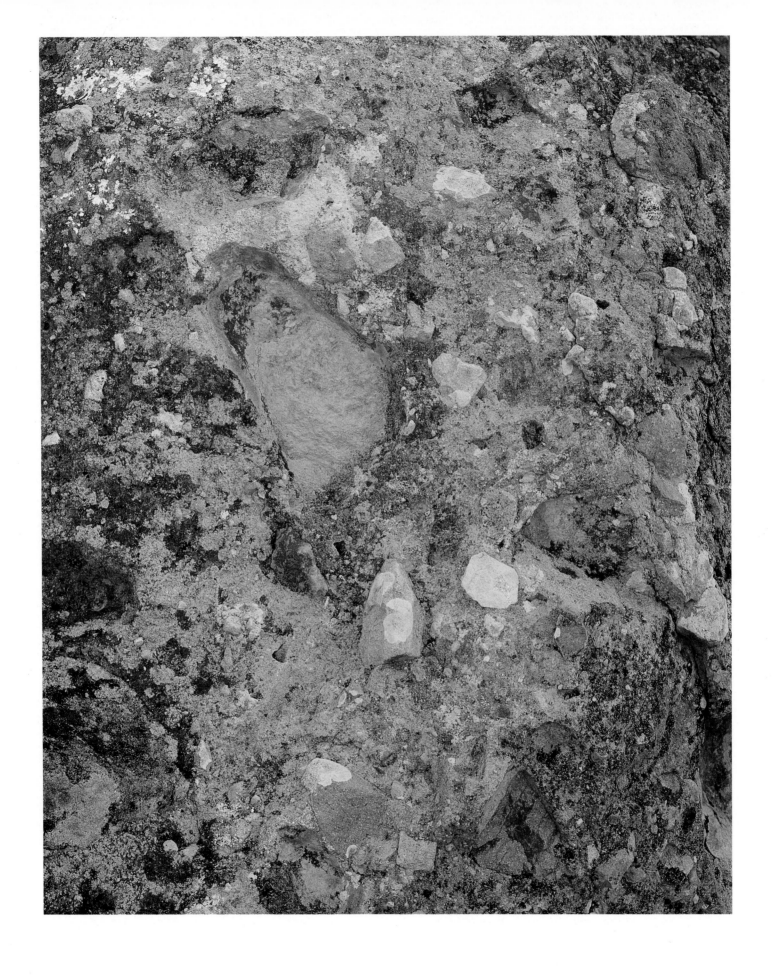

Lichens on boulder, San Javier, Baja, California, 9 March 1964

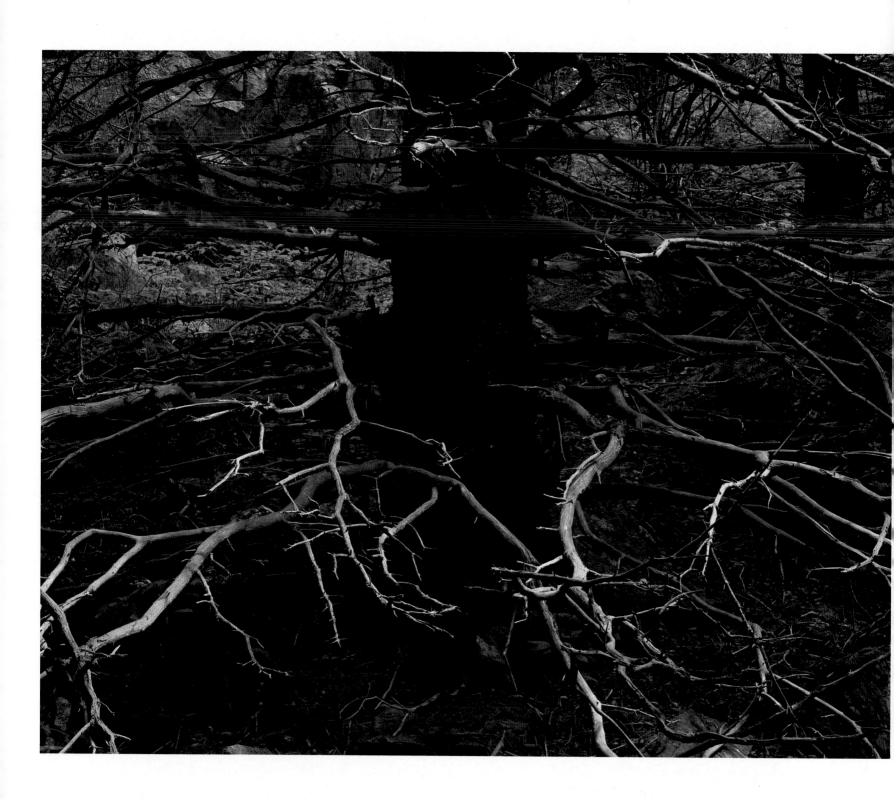

112.　　*Lower dead branches of spruce tree, Great Spruce Head Island, Maine, 10 July 1976*

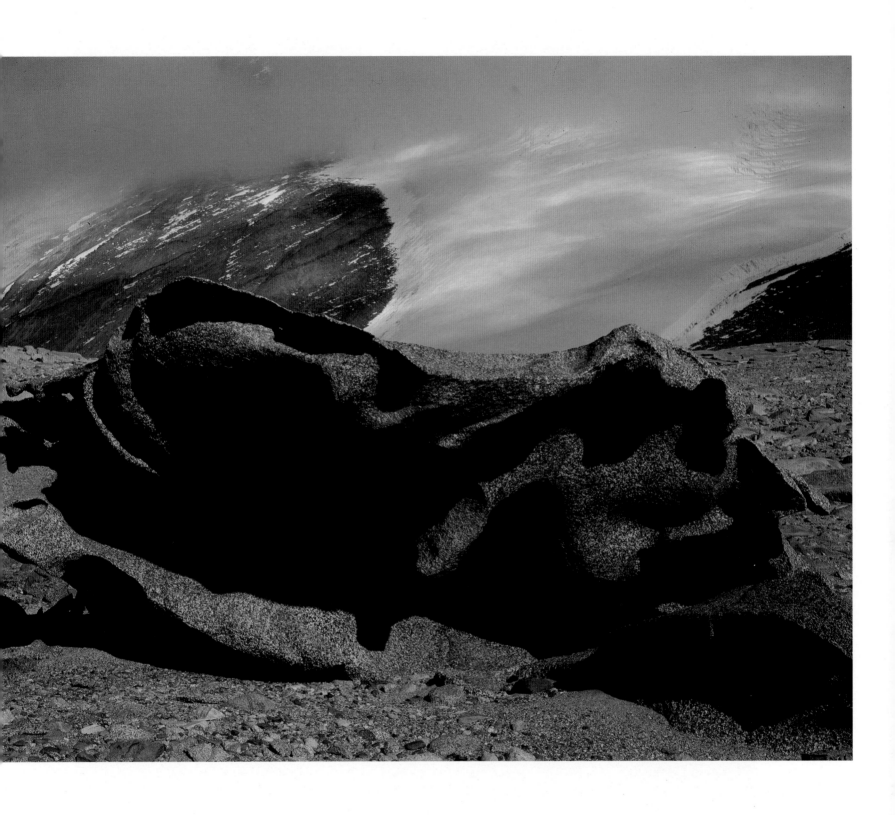

Cove weathering and Calkin Glacier, from Mt. Thomson, Taylor Valley, Antarctica,
18 December 1975

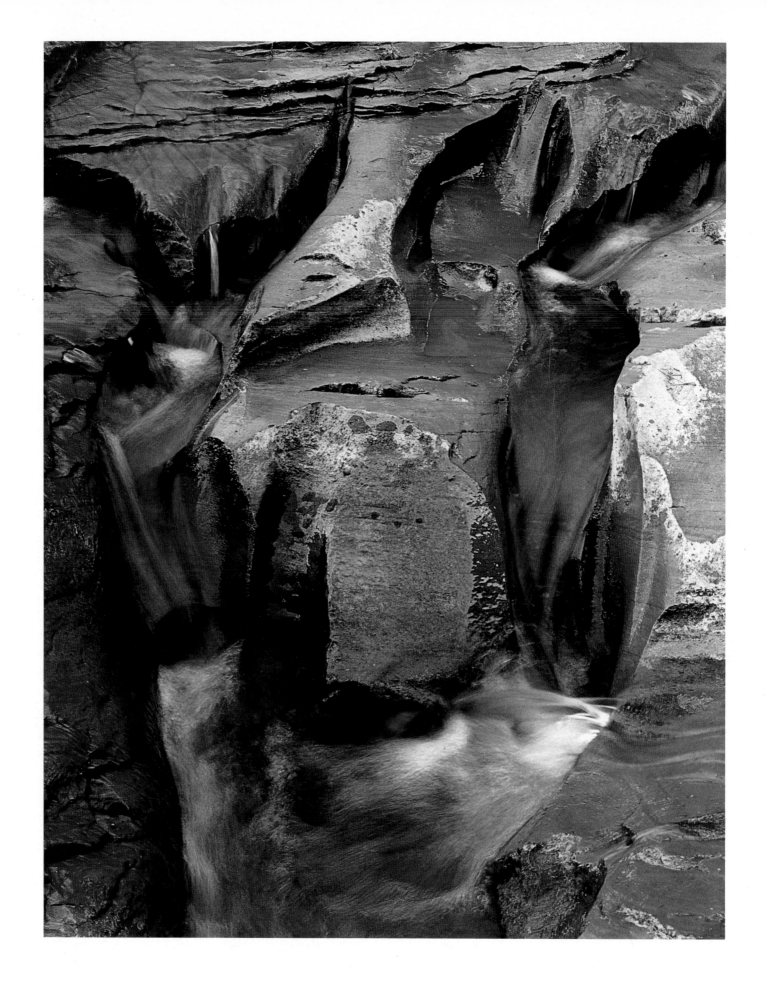

Rock-eroded stream bed, Coyote Gulch, Utah, 14 August 1971

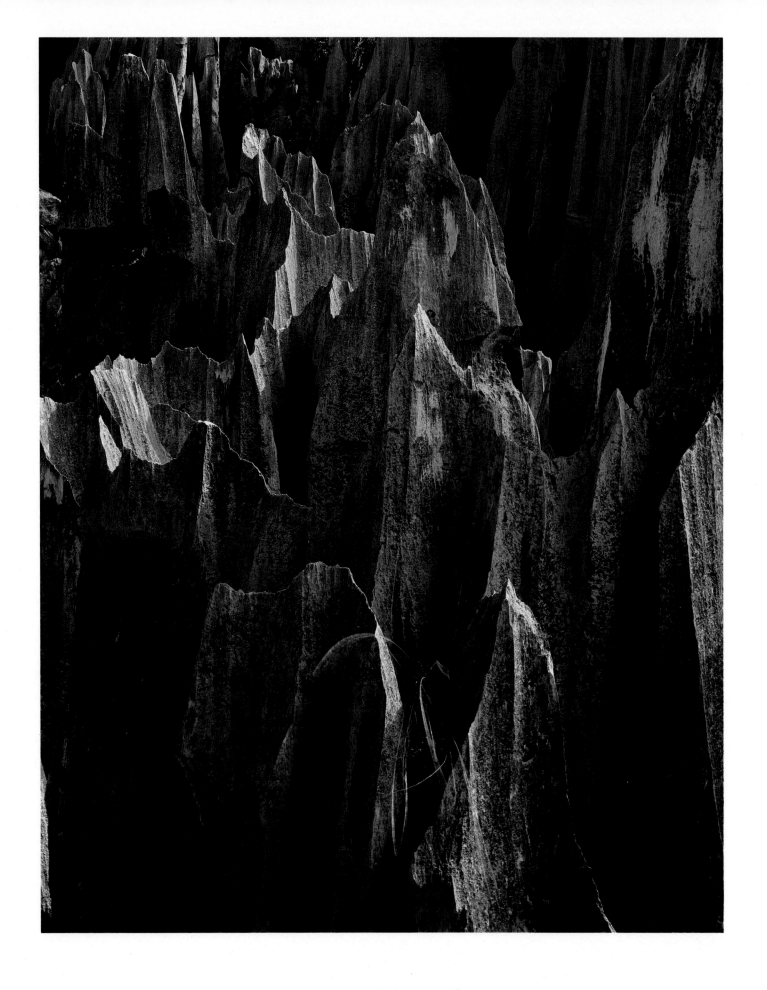

Rock spires, Stone Forest, Kunming, Yunnan, China, 26 October 1981

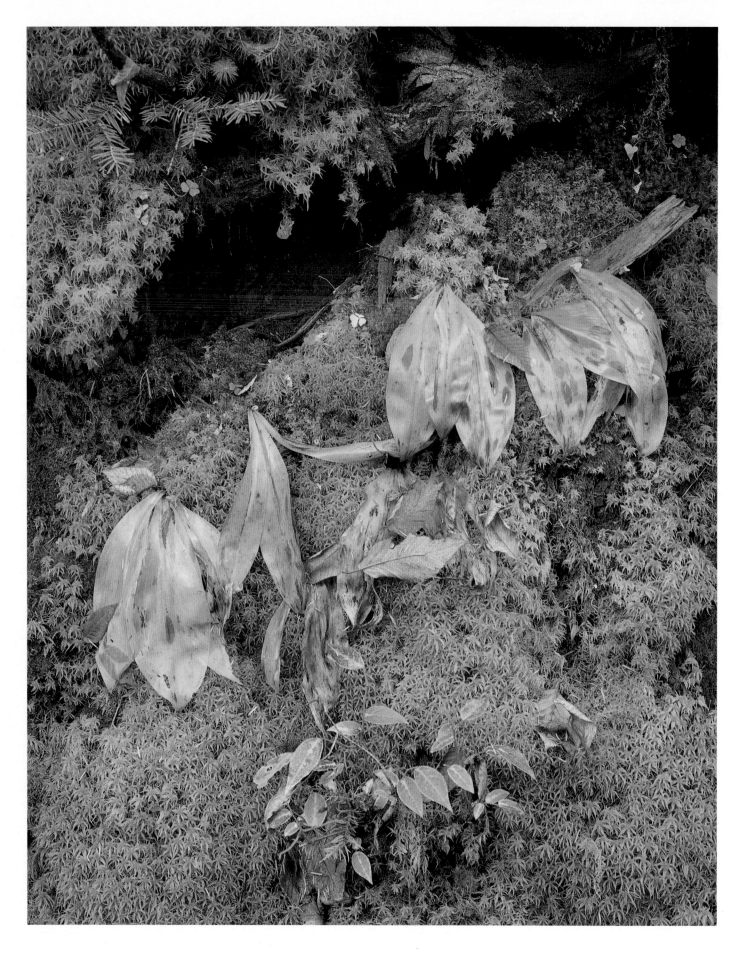

Bleached leaves and moss, The Appalachian Trail, Great Smoky Mountains
National Park, Tennessee, 11 October 1967

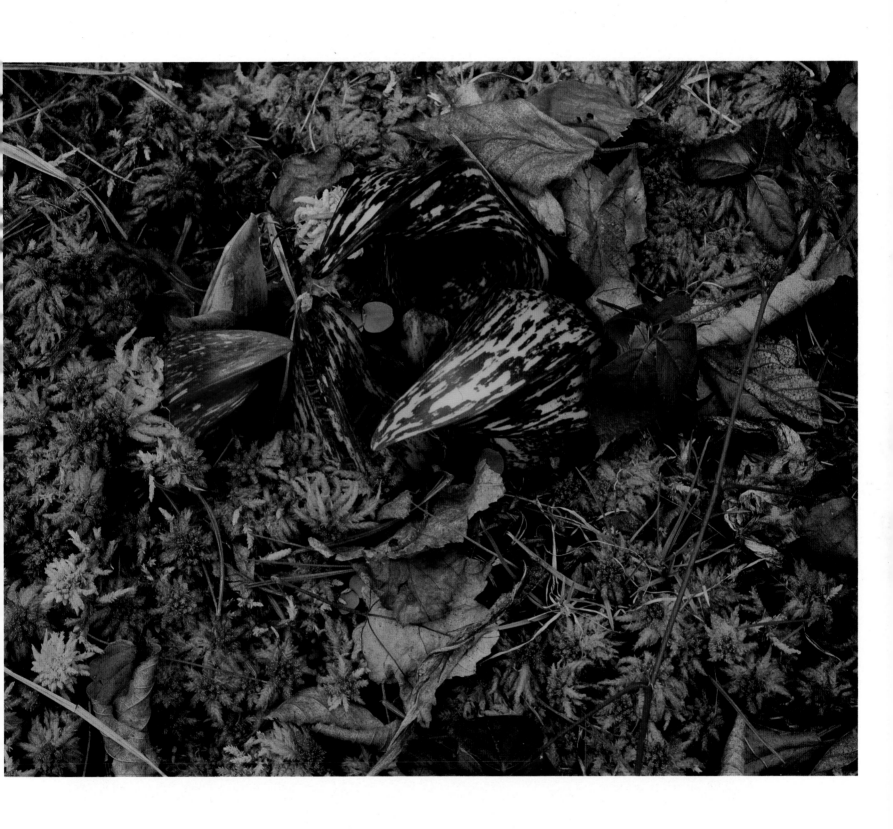

Skunk cabbage flowers, near Great Barrington, Massachusetts, 19 April 1957

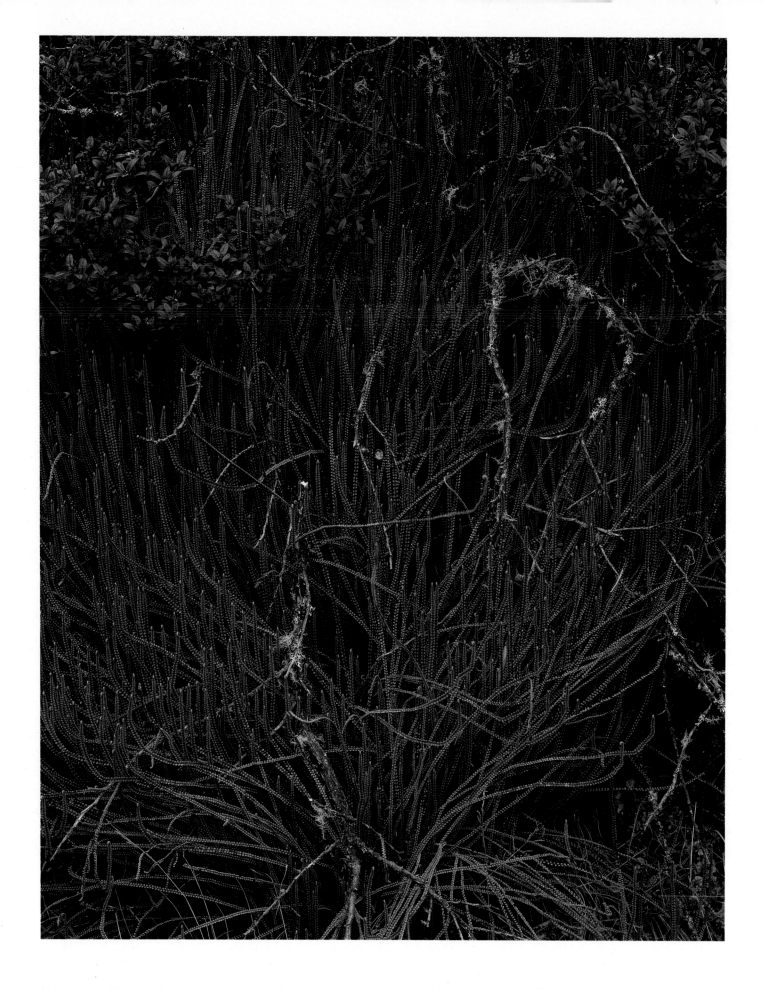

122. *Jamesonia fern and paramo, Cerro de la Muerte Park, Costa Rica, 15 March 1984*

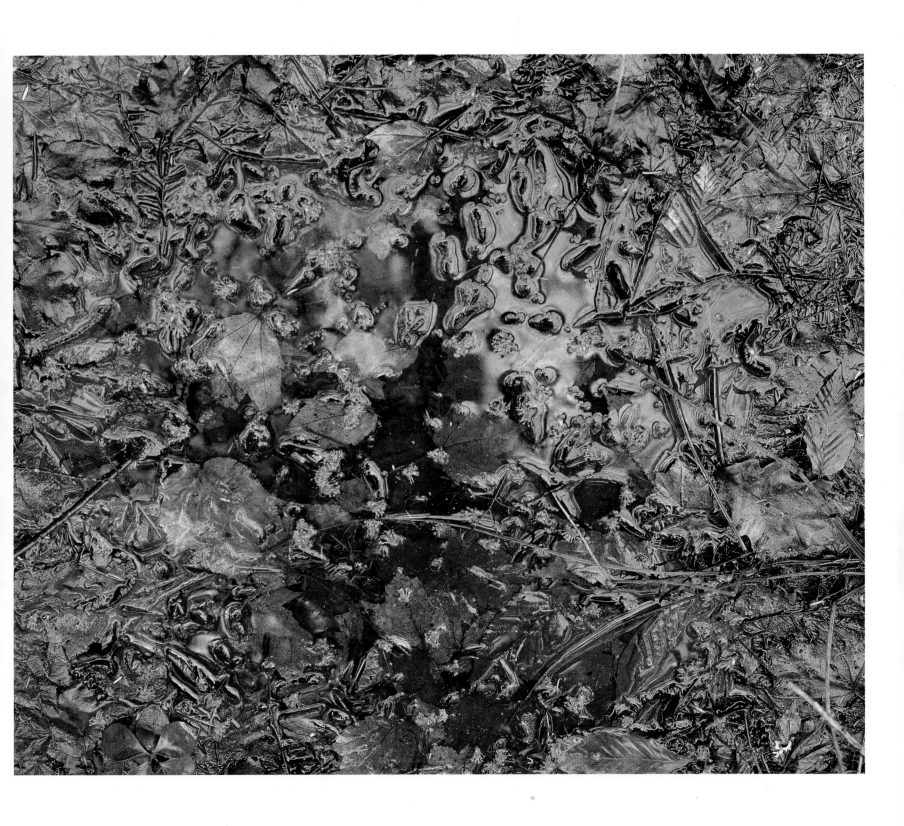

Maple blossoms in puddle, Chocorua, New Hampshire, 7 May 1961

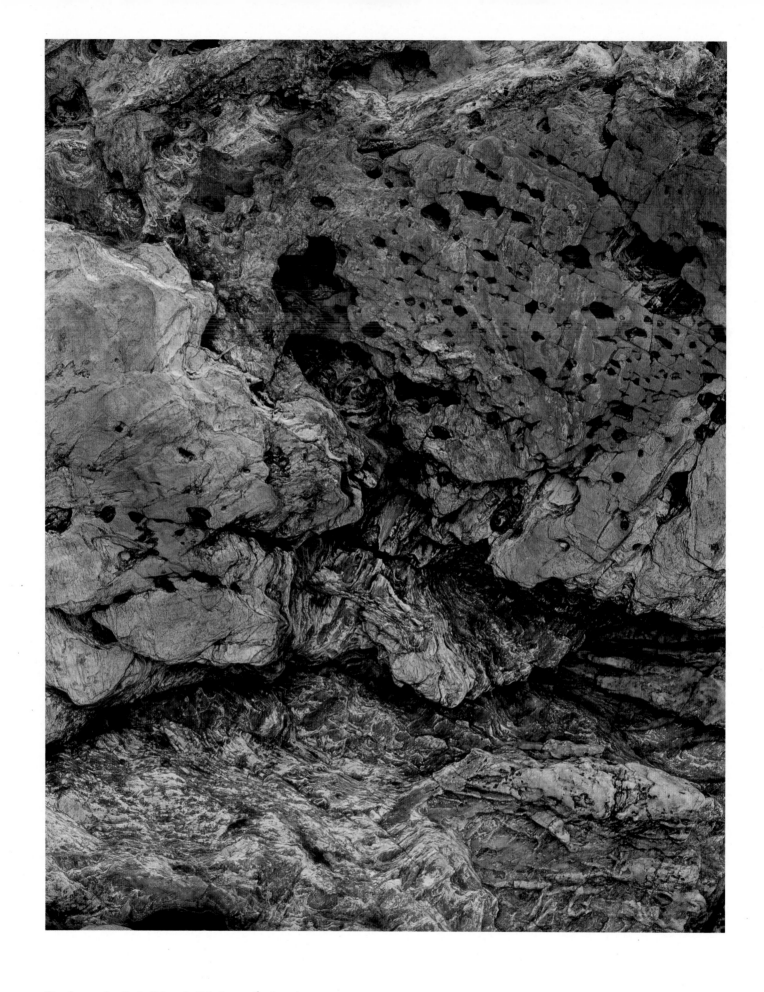

Gneiss rock, Oak Island, Maine, 26 August 1973

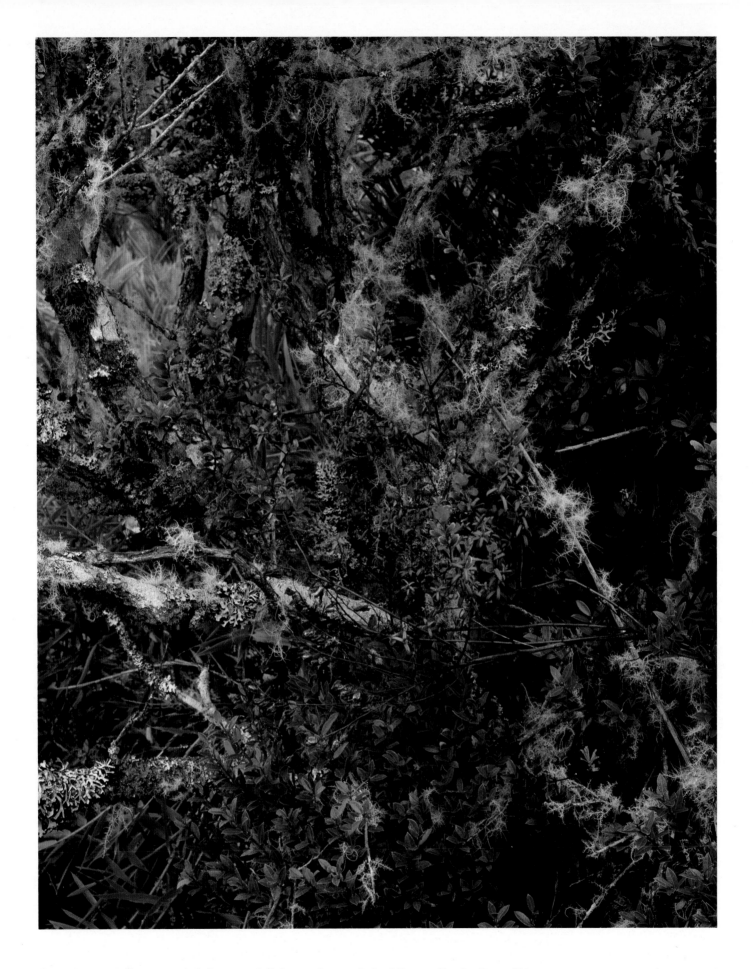

Paramo, red flower, vaccinium, and lichens, Cerro de la Muerte Park, Costa Rica,
15 March 1984

Sources and Further Reading

Barnsley, Michael, *Fractals Everywhere* (Orlando: Academic Press, 1988).

Mandelbrot, Benoit, *The Fractal Geometry of Nature* (New York: W. H. Freeman, 1977).

Smith, Cyril Stanley, *A Search for Structure* (Cambridge, Mass.: MIT Press, 1982).

Stevens, Peter S., *Patterns in Nature* (Boston: Atlantic Monthly Press, 1974).

Set in monotype Walbaum by Michael and Winifred Bixler

Designed by Eleanor Morris Caponigro